D0773562

THE FIVE HAPPINESSES

THE

EDOUARD CHAVANNES

FIVE HAPPINESSES

SYMBOLISM IN CHINESE POPULAR ART

translated, annotated, and illustrated by

ELAINE SPAULDING ATWOOD

with a foreword by

ARTHUR W. HUMMEL

New York · WEATHERHILL · *Tokyo*

78-179455-7

HOUSTON PUBLIC LIBRARY

R01 0838 9814

Originally published as "De l'expression des voeux dans l'art populaire chinois," Journal asiatique, *series 9, vol. 18 (September–October, 1901), and reprinted in book form as* De l'expression des voeux dans l'art populaire chinois *in 1922 by Editions Bossard, Paris*

First English Edition, 1973

Published by John Weatherhill, Inc., 149 Madison Avenue, New York, New York 10016, with editorial offices at 7-6-13 Roppongi, Minato-ku, Tokyo 106. Protected by copyright under terms of the International Copyright Union; all rights reserved. Printed and first published in Japan.

Library of Congress Cataloging in Publication Data: Chavannes, Édouard, 1865–1918. / The five happinesses. / Translation of De l'expression des voeux dans l'art populaire chinois. / "Selected bibliography of works by Édouard Chavannes": p. / Bibliography: p. / 1. Symbolism in art. / 2. Folk art—China. / I. Atwood, Elaine Spaulding, ed. / II. Title. / N7740.C4413 / 745'.0951 / 72-92098 / ISBN 0-8348-0076-4

To the memory of my teacher

Alice T. Ch'en

CONTENTS

FOREWORD

Iᴛ ᴡᴀꜱ ᴀ ʜᴀᴘᴘʏ ᴛʜᴏᴜɢʜᴛ to make available to the English-speaking world the reflections of a great French scholar on the symbols and decorations that appear on objects of Chinese art. These objects have long accumulated in our homes and museums—ever since the first American ship, the *Empress of China,* landed at Canton in 1784. Though we have learned to prize them as ornaments, we too often gloss over their inner meanings. In her book, Elaine Atwood has done more than put into English a neglected French classic; she has enriched it by her own observations and by consultation with others.

The higher reaches of our thinking cannot easily be put into words. Yet understanding is enhanced by the use of signs and symbols. What is important, then, is not the objects themselves, but what their decorations suggest. Symbols point to meanings beyond visible forms: they are shorthand for further comprehension. Through them we get glimpses into the mentality of people who lived for millenniums under different skies.

China's art is an unconscious reflection of a people's way of life: their hopes, their ambitions, their inmost desires. Her artists and writers—more than in most countries— were sustained by moral and ethical ideas. They found that symbols served best when referring to things timeless and eternal. We miss these intentions, however, if we gloss over what the symbols say.

Fortunately, there is nothing mysterious about all this. The objects themselves are all about us: porcelains, bronzes, amulets, embroideries, furniture. Obviously not all decorations could be explained here. But hopefully—from the examples which this book provides—observers may penetrate further. In a world where mediation between cultures is still so deficient, a book like this can, in a modest way, help to fill the need. It can be a step toward "gathering the springtimes of the world into our minds"—to use an expression of the eleventh-century Chinese scholar Shao Yung.

Aʀᴛʜᴜʀ W. Hᴜᴍᴍᴇʟ
Former Chief, Division of Orientalia
Library of Congress

TRANSLATOR'S PREFACE

As anyone knows who has ever ground Chinese ink on an inkstone, there is a great deal more to Chinese painting than picking up a brush. Literature, history, philosophy, religion, and calligraphy are all essential parts of it. A beautifully written ideograph with its balance and its rhythmic line is an example of the finest in abstract painting, with a living quality that has developed from its having been done many times by many hands, each writer trying to give of his best.

There is also a shadow language of symbolism parallel to the written characters, a language that can be read in the design on a plate or a textile as easily as if it were a piece of calligraphy. This has nothing to do with "picture writing" and should not in any way be confused with it, being instead a matter of plays on words—visual puns and rebuses. The overworked statement that every picture is a poem and every poem a picture comes as close as anything to putting the nature of this symbolic language into words, but even that does not entirely express it.

When I first began to realize how real a language this symbolism is, in the course of studying Chinese painting and the Chinese language, I started collecting the designs of which it seemed to be made up and, for my own pleasure, working them into a portfolio of drawings made from ordinary objects of popular art—dishes, textiles, brassware—articles of everyday household use, some from my friends' collections and some from my own, but nothing of museum value and nothing from photographs or drawings by anyone else. This portfolio grows constantly as I keep finding new examples to add and because my friends have become interested to the extent that on finding a piece of silk or embroidery, a dish, or other Chinese objects, they bring them to me to see if I would like to record the designs.

The problem of preparing a text to go with the drawings was a real one, since I do not read Chinese easily and had to rely on what others had already written rather than go to primary sources as I had for the drawings. There are superb books on symbolism, which I consulted but which did not tell me quite what I wanted to know. Then I found a French study, written by Edouard Chavannes and first published in 1901, *De l'expression des voeux dans l'art populaire chinois,* which interprets the symbolism of Chinese decorative art. Here was a book that seemed to fit my drawings as if I had made them for it, and that told

11

me exactly what I had been seeking. When the Library of Congress advised me that it had listings of only two copies of this work in the United States, I decided to translate it, feeling that since I had found it to be of such value, it might be of equal interest to others and should be made available in English. Edouard Chavannes, with his vast knowledge of the language, could go to Chinese sources for his interpretations of the symbolism of popular art and thus was able to open an approach to the subject that is not available to most.

In translating, one inevitably loses a certain amount of the flavor of the original, but I have tried to preserve some of the formality of the scholarly French in which Chavannes wrote. Although the book contains certain statements that were entirely true of China at the time he wrote them, but which in our time may no longer be so, I have not tampered with his text because such statements are not basic to the subject of the book and in no way affect the validity of Chavannes's elucidation of the symbolism expressed in the popular art of China, this being timeless.

In a study like this it is necessary to include the Chinese characters as well as the transliterations and translations of words and phrases because, given the nature of the Chinese language, the romanized syllable standing for a Chinese word can have any of several meanings, the appropriate one being determined by the ideograph used; thus the nature of Chinese puns and rebuses is made clear only by seeing the ideographs concerned.

I would like to express my deep appreciation to Dr. Arthur W. Hummel of the Division of Orientalia of the Library of Congress and to Dr. John A. Pope of the Freer Gallery of Art for the advice and encouragement they have given me.

EMMANUEL EDOUARD CHAVANNES was born on October 5, 1865. His parents had emigrated from France to Geneva, Switzerland, and had become Swiss citizens. However, he was born in Lyon, France, where his father, an engineer, was technical director of the Ateliers de la Buire.

He attended school in Lyon and Lausanne, and in 1885 was admitted to the Ecole Normale in Paris. He also studied Chinese concurrently at the Lycée de l'Orient. In 1888 he obtained both his fellowship in philosophy and his diploma in Chinese.

In 1889 Chavannes was sent to China, where he lived at the French Legation in Peking for three years as an attaché-at-large, perfecting himself in the languages and dialects of China. He also did a great deal of work on ancient Chinese texts during this period.

In 1891 he returned to France, where a chair of philosophy was reserved for him at the Lycée de l'Orient, but instead of accepting this position he took the examination in the Department of Foreign Affairs. That same year he married Alice Dior, daughter of a

physician. At the end of the year he went to Peking again, returning to Paris in April, 1893, to become at twenty-seven years of age the assistant to Hervey de Saint-Denis at the Collège de France, teaching Chinese and Manchu. That same month he succeeded Saint-Denis as a professor of the Collège de France, a position he held until his death.

In 1907 Chavannes journeyed across Siberia to northeastern China, where Sir Aurel Stein was uncovering a rich treasure of Buddhist art and archives in the caves of Tun-huang. Here Chavannes made a valuable collection of documents and drawings and deciphered ancient inscriptions, including some on wood slips discovered at Tun-huang.

Chavannes had been made a member of the Société asiatique in 1888 and a member of the Académie des inscriptions et belles-lettres in 1903; he became president of the Académie in 1915. He died in Paris, at the peak of his intellectual powers, on January 20, 1918, at the age of fifty-two.

It is only in reading the titles of Chavannes's publications listed in the Selected Bibliography that we can begin to realize how colorful his life must have been and how broad his interests. The simple outline of the known facts of his biography leaves to our imagination the many adventures he must have had and the excitement he must have felt in exploring and in discovering ancient records of Chinese religions, rites, folklore, literature, and customs. We imagine long expeditions into the interior of China—mule trains, camel caravans, dust storms, bandits, and evenings around the campfire discussing the day's finds.

When Chavannes began his work, systematic study of East Asia was in its infancy. He was instrumental in discovering and translating the works of Chinese historians and geographers and the tales of Buddhist pilgrims. He investigated an extremely wide spectrum of art, archaeology, and philosophy, and translated a number of ancient texts. Chavannes wrote a number of monographs and contributed many papers to such journals as *Annales du Musée Guimet*, *Bulletin de l'Ecole française d'Extrême-Orient*, *Journal asiatique*, *La revue de l'histoire des religions*, and above all *T'oung pao*, which he edited with Henri Cordier from 1904. He also edited the first volume of the series *Ars Asiatica* with Raphaël Petrucci. The great work of his life was the five-volume *Mémoires de Se-ma Ts'ien*, a translation of the *Shih-chi*, a history of China from earliest times to about 100 B.C. by Ssu-ma Ch'ien (145– 74? B.C.)—a project left unfinished by Chavannes's untimely death. Among Chavannes's gifted students were Bernhard Karlgren, Henri Maspero, and Paul Pelliot, all of whom were to become great Sinologists.

When the scholar and writer Raphaël Petrucci died in 1917, his widow asked Chavannes to supervise the publication of Petrucci's translation of the Ming-dynasty treatise on painting *The Mustard Seed Garden* (*Chieh-tzu Yüan Hua-chuan*), which Petrucci had

completed but which, because of World War I, had not yet been published. This Chavannes did; and the dedication that he wrote as a tribute to Petrucci, only a year before his own career was cut short, is appropriate to quote in part as a tribute to Chavannes himself:

"Those who read these pages will appreciate the full import of the loss that has come to us in the death, at the height of his intellectual vigor, of this enthusiastic seeker of knowledge, whose vast erudition, sure taste, and philosophical views have helped us to understand and love the art of painting in the Far East."

THE FIVE HAPPINESSES

THE FIVE HAPPINESSES

The decoration on articles of everyday use in China is nearly always symbolic; it expresses good wishes. To prove the truth of this statement, one has only to look at things used by everyone, embroideries, letter paper, amulets; everywhere we find reproduced motifs of ornamentation that have a meaning. This meaning is perhaps more or less hidden, but it must be deciphered if one wishes to understand the reasons for the designs.

In order to clarify our study, we will begin by analyzing, one by one, the different ways in which these ideas are expressed; we will then seek to enumerate and clarify the ideas themselves.

One way of expressing an idea consists in writing, purely and simply, the words that indicate it. Chinese writing, with the great elegance of its characters and the variety of forms that one can give them, is admirably suited for use as ornament. We therefore find numerous objects on which calligraphy alone serves as decoration, such as the vases on which one reads the character *shou* 壽, or longevity, repeated a hundred times in a hundred different forms.

A second means of expression is through a symbol with which there is an association of ideas: thus an ingot of gold represents riches; a book, learning or knowledge; a pomegranate, because of its many seeds, numerous descendants.

Besides these associations of ideas, which are natural and self-explanatory, there are others that are peculiar to the Chinese, and for which the reasons are often difficult to discern. They are frequently founded upon a reference to the classic texts with which Chinese thought is so filled. A poem from *The Book of Odes*[1] celebrates the sons, grandsons, and parents of a prince, comparing them, respectively, to the feet, the forehead, and the horns of the fantastic animal known as *lin* 麟 or *ch'i lin* 麒麟, which Westerners have likened vaguely to the unicorn. The image of this creature thus evokes for the Chinese the idea of an illustrious posterity.

But in other cases, the symbolism can be explained solely by conjecture. I will cite only one example. The dragon is a favorite subject; it is represented with a ball, and it is commonly said that the dragon plays with a pearl. The dragon represents excellence.

[1] *Che King,* section "Kouo Fong," book 1, ode 11.

Why is this? The dragon presides over the waters and the rain; in times of drought it is invoked in the hope that abundant rain will come and save the crops. It is natural, therefore, that to an agricultural people, such as the Chinese, the dragon, bringer of fertility to the fields, should become the symbol of whatever is most powerful and best in the world.

Then what is this disk, so improperly called a pearl by the uninformed? There is a theory that it is the sun, which was forced by the rain clouds to hide. But Hirth has suggested a more reasonable explanation:[2] he calls to our attention the small volute that is always found within the disk; this volute also appears in certain designs on the drums that the thunder god beats; it is the image of the rolling of thunder. Indeed, the written character indicating thunder was originally formed of a single line turned back upon itself. Therefore the disk with which the dragon plays is the thunder, the sinuous lines surrounding him are the clouds, and it is an ancient myth of the storm that is thus depicted.

Could one go further and show why the dragon presides over the rain? The dragon has paws and scales, recalling the alligator, which existed in ancient times in the rivers of China and of which there still remain a few rare specimens in the Yangtze River.[3] The alligator, an aquatic animal, is naturally associated with the idea of the waters; it hides in winter, but in the spring and at the beginning of summer, the time of the great rains, it appears for its frolics. The Chinese have taken the effect for the cause, and have said that the clouds accompany the dragon.[4] Thus the alligator has become a supernatural being, bringer of clouds; thus the imagination of artists has made of it a fantastic and auspicious animal; thus the memory of the role given it in storms is marked in the disk of the thunder and in the clouds among which it plays; and finally, thus has arisen the idea of fertility, brought by the rains, transforming the dragon into a symbol of excellence.

But at the same time, one realizes the long series of inductions that must be made in order to reconstruct the sequence of these associations of ideas, and how much of hypothesis there still is in the explanation of this symbol, which is nevertheless one of the easier to penetrate. We will not pursue further this type of research, interesting though it may be; our goal is to indicate the actual meaning of symbols and not to establish, more or less hypothetically, their origin, because this even the Chinese themselves no longer remember, so remote is it.

A third means of expression consists of indicating words by using images that suggest

[2] Friedrich Hirth, "Über den Mäander und das Triquetrum in der Chinesischen und Japanischen Ornamentik." *Chinesische Studien,* vol. 1, pp. 231–42.

[3] Cf. A. Fauvel, "Alligators in China." *Journal of the China Branch of the R.A.S.,* new series vol. 13, pp. 1–36.

[4] Cf. J. J. M. de Groot, *Les fêtes annuelles à Emoui,* pp. 361–71.

the pronunciations of these words, this being the ordinary device of the rebus. An amulet in the Musée Guimet presents on one of its faces a halberd, *chi* 戟; a sonorous stone, *ch'ing* 磬; and one of those scepters of honor known as *ju-i* 如意. The expression *ju-i* means "May it be as you wish," or "According to your wishes." The solution of the rebus is given us on the reverse of the piece, where we read the words *chi ch'ing ju-i* 吉慶如意, "May your luck and your fortune be as you wish." The halberd, *chi* 戟, suggests the idea of the homophone *chi* 吉, which means "good luck." The sonorous stone, *ch'ing* 磬, is the phonetic equivalent of the word *ch'ing* 慶, "good fortune." Finally, the scepter has the name *ju-i* 如意, that is, "as you wish." The same rebus is found in an illustration of a popular edition of a collection of tales called *Liao-chai Chih-i;*[5] one sees on the table of a scholar a vase in the shape of an elephant, containing a halberd, a sonorous stone, and a scepter.

On the foot of a vase in the Grandidier Collection, we note the following four designs: a Chinese writing brush in the center of a wheel, which can be written *pi chung* 筆中, "The brush passes through the center," but which written in another way, *pi chung* 必中, signifies "Certainly you will succeed." The second design is formed by a lotus flower, *lien* 蓮, and a flute, *shêng* 笙, which through similarity of sound means *lien shêng* 連陞, "May you be continuously promoted." Then there are the halberd, *chi* 戟, and the sonorous stone, *ch'ing* 磬, which we have already found on the amulet and which convey, again through similarity of sound, the meaning of *chi ch'ing* 吉慶, "Good luck and good fortune." Finally, an ingot of gold, *ting* 錠, and a scepter, *ju-i* 如意, indicate the formula *i ting ju-i* 一定如意, "May it surely be according to your wishes." A jar, *p'ing* 瓶, a saddle, *an* 鞍, and a scepter, *ju-i* 如意, suggest the phrase *p'ing an ju-i* 平安如意, "May you have tranquillity conforming to your wishes."

The pun is not unknown in the arts of the Aryan race. If the butterfly has become, in Greek art, the emblem of the soul, it is originally, as Collignon has so well pointed out,[6] because of a simple play on words: *psyche* was the name of a nocturnal butterfly; it was then chosen to represent the homophone *psyche*, "soul." In China the butterfly, *tieh* 蝶, represents the word *tieh* 耋, which signifies "the age of seventy or eighty." The same symbol thus has different meanings in Greece and in China, because it rests on relations that are purely verbal, and these relations naturally differ in Greek and in Chinese.

The pun has, in addition, been able to assume in China an extension impossible any-

[5] By Pu Sung-ling (1640–1715); first printed in 1766. For a sketch of this author, see Arthur W. Hummel, *Eminent Chinese of the Ch'ing Period* (Washington, D.C., Library of Congress, 1944), vol. 2, pp. 629–30. —Trans.

[6] A. Collignon, *Essai sur les monuments grecs et romains relatifs au mythe de Psyché*, pp. 6, 7.

where else, because of the monosyllabic nature of the language. In French most homonyms are monosyllables; nothing distinguishes to the ear the *poing* of the closed fist and the *point* of geometry; a *port* of the sea, the majestic *port* of a queen, and fresh *porc;* a *chaine* for enchaining and the tree that is called *chêne.* If we add that in China not only are the words monosyllables but, in addition, there are no articles and nothing distinguishes the termination of a masculine word from that of a feminine, one can understand what an infinite variety of puns can be imagined. It is not at all surprising that this peculiarity of the language has developed, under conditions unknown elsewhere, this role of play upon words.

A fourth form of symbolism consists of the representation of personages who, for one reason or another, evoke a certain idea. One often sees on porcelains two young boys with a joyful air, who always appear together; these are the *ho-ho,* thus named from two words: *ho* 和, which signifies "concord," and *ho* 合, which signifies "union"; or *ho-ho liang shên hsien* 和合兩神仙, "harmonious immortal pair." These two personages are therefore the symbol of agreement and harmony.

The number of such personages being rather considerable, it would be difficult to distinguish them one from another if one did not have recourse to a procedure familiar in the symbolic art of every land; they are given attributes that permit their recognition with complete certainty. In the case of the two *ho-ho,* the attributes are determined by a simple pun: one of them carries a waterlily, *ho* 荷; the other, a round box, also called *ho* 盒; these two attributes presenting through similarity of sound the name, *ho-ho,* of these personages.

This leads us to consider a fifth and last form of symbolic expression: because what is important in a personage is his attribute, one can, in certain cases, represent only the attribute, this attribute being the symbol of the personage, who is himself the symbol of an idea. An amulet in the Musée Guimet shows this procedure, combined with that of the rebus: on one side, we find the waterlily, *ho* 荷, and the box, *ho* 盒, attributes of the two *ho-ho,* as well as a scepter, *ju-i* 如意. On the reverse, we find the phrase *ho-ho ju-i* 和合如意, "May there be harmony in accord with your wishes." This amulet can be explained by the simple rebus, but it is also possible that in using the words *ho* 和 and *ho* 合 to suggest the attributes of the two *ho-ho,* it was desired in addition to indicate the idea of these personages themselves.

These being the principal methods used in Chinese symbolism, we can now examine what ideas are to be expressed.

The wish most natural to man is that of being happy. The wish for happiness is thus

one of those most often found. The characters *fu* 福, "happiness," and *hsi* 喜, "joy," which appear on a great number of vases and embroideries, are the simplest expression of this wish. Symbolically, the dragon, which is known as the most nearly perfect of beings, is also associated with the idea of happiness; in this case he is often facing a marvelous bird, the *fêng* 鳳 or *fêng huang* 鳳凰, generally known as the phoenix, although the Greek fable of the phoenix that is reborn from the ashes has nothing in common with the Chinese traditions regarding the *fêng*. The dragon and the phoenix announce or foretell happiness: *lung fêng ch'êng hsiang* 龍鳳呈祥, "The dragon and the phoenix foretell good luck."

The procedure of the pun brings us the bat, whose name, *fu* 蝠, is pronounced like the word *fu* 福, "happiness." The bat, which would hardly be acceptable to us as a gracious emblem, is one of the most frequently used motifs of Chinese design; it is frequently modified to a point where it no longer possesses more than a distant resemblance to reality. But when one has seen all the steps that lead to this conventionalized form, one ends by recognizing it in many places: on the clasps or as the corners of boxes, on the hooks of belts, on teapots, and on a thousand objects of domestic use, where it repeats endlessly the wish for happiness.

Another play upon words is one that consists in representing happiness by showing one of those strange citrons that grow in the south of China and of which the upper part is divided into numerous branches, similar to the fingers of a hand. These are called *fo shou* 佛手, "hands of Buddha," and since the word *fo* is similar in sound to the word *fu,* "happiness," this citron has, in the same manner as the bat, become one of the images of happiness.

By one of those mysterious affinities that establish, according to our temperament, the relations between certain sensations and certain sentiments, the color red is in China the color of joy; the usual feeling produced by this color is the sentiment of joy. A species of small spider whose body is red in color has been named, because of this, *hsi* 蟢, "joy," and is a natural symbol for the idea of joy. On an envelope is a drawing of a box that has been opened; in the raised lid appears a spider web, and the insect itself dangles from it on the end of a thread. The following inscription accompanies this vignette: *k'ai fêng chien hsi* 開封見喜, "When one opens that which is sealed [the box], one finds joy [the spider]." This phrase could also be understood in the following manner: "When you open that which is sealed [the envelope], you will see a subject of joy [the letter that it contains]."

On a sheet of letter paper one finds two spiders, and above them this verse by a poet:

hsi tao yen ch'ien mei shih shuang 喜 到 檐 前 每 是 雙: "When joy [the spider] arrives beneath the eaves, it is always double"; which is the contrary of our unhappy saying that misfortunes never arrive singly.

These two spiders are the exact symbolic equivalent of the artificial character formed in calligraphy when the character *hsi* 喜 is doubled; this is known as *shuang hsi* 雙喜, or "double happiness," and gives a rather nice decorative effect.

What, exactly, is "double happiness"? The answer is given us with the greatest precision by a small vase in the Musée Guimet, on whose body the double character *shuang hsi* is written six times and on whose neck is shown the formula *fu shou shuang ch'üan* 福 壽 雙 全: "May happiness and long life both be complete." Double happiness, then, is composed of happiness itself and of longevity. Before examining the way in which the Chinese symbolically express this double idea, it would be well to examine first how they express the concept of longevity alone.

The Chinese consider a long life to be infinitely desirable; they honor old age, perhaps even to excess, since the "gerontocracy," that too considerable part given in public affairs to men whose great age renders them slow to accept any innovation, is one of the reasons that make China so obstinate in the face of progress.

One of the most appreciated gifts that children can give their parents is a robe ornamented with the character *shou* 壽, "longevity." The recipient wears it on feast days, and especially on anniversaries, because the presence of this word augments the vital energy. The dead are covered with it in the tomb in order that this longevity may extend to their descendants. A red label with this character signifying longevity is pasted on coffins in order that this amulet may ward off the influence of death that could emanate from a funerary object.

The idea of longevity may be expressed by various symbols: first there is the fungus *chih* 芝, a species of mushroom that, if picked at the beginning of winter, is preserved without any change. It is called the "divine fungus," *ling chih* 靈芝, and is said to confer immortality. The scepter of honor, *ju-i* 如 意, which is given as a present, and of which the Musée Guimet possesses a splendid collection, is a sort of crosier whose top has the form of a fungus head. The meaning of this object, therefore, is that the giver wishes for the one upon whom he bestows it longevity according to the recipient's wishes. A book about the immortals tells of a man who, after having eaten a mushroom, found himself to be rejuvenated, and a Taoist predicted that he would "live as long as a tortoise or a crane": *shou têng kuei ho* 壽 等 龜 鶴.

This phrase leads us to consider those symbols of longevity the tortoise and the crane.

Liu An,[7] in the second century B.C., maintained that the tortoise lives three thousand years and the crane a thousand years.[8] A similar belief explains this inscription on an amulet: *kuei ho ch'i shou* 龜鶴齊壽, "May you have longevity equal to that of the tortoise and the crane." Candlesticks are often made in the form of a tortoise on which a crane is standing, holding in its beak a *ling chih* 靈芝, "fungus of immortality." Amulets show a pair of cranes mounted on tortoises, at their feet an incense burner, which suggests the idea of prayers made to the gods in order to obtain longevity.[9] The crane is frequently represented beneath a pine because the pine, with its evergreen foliage, is also a symbol of perpetuity. It is a common expression to say *sung ho ch'ang ch'un* 松鶴長春, "May you have a perpetual springtime like the pine tree and the crane." Finally, the crane often appears with the deer, which is said to live to a great age.

Another emblem of longevity is the peach; the reason for this is not evident. The red color of the fruit, happy color above all others, and its excellent flavor could have contributed to its having been chosen as the emblem of the most wished-for of happinesses. But better even than these considerations, the extremely ancient legends of the Queen Mother of the West, Hsi Wang Mu 西王母, the fabulous sovereign of the mythological mountains of Central Asia, who possesses the supernatural peach tree whose fruits ripen every thousand years and confer immortality on those who eat of them, could have given the peach its marvelous renown.

A hairpin, shown by de Groot in his beautiful book on the religious system of China,[10] has as pendants a peach, *t'ao* 桃; a tortoise, *kuei* 龜; a deer, *lu* 鹿; and a crane, *ho* 鶴; all four of which are emblems of longevity.

Other symbols explained by puns include the following: the word *mao* 猫, "cat," suggests the homophone *mao* 耄, which signifies "the age of ninety years"; and the butterfly, *tieh* 蝶, which represents the word *tieh* 耋, signifying "the age of seventy or eighty years." Similarly, in the vegetable kingdom the narcissus, *shui hsien* 水仙, the "water fairy," is because of this name a symbol of immortality or, failing that, of long life.

Let us return now to the ideas combining happiness and longevity and review some of the innumerable forms through which they are expressed.

[7] Commonly known as Huai-nan Tzu, or Prince of Huai-nan. Cf. Herbert A. Giles, *A Chinese Biographical Dictionary* (London, Bernard Quaritch, 1897), no. 1269. —Trans.

[8] Cf. V. R. Burkhardt, *Chinese Creeds and Customs* (Hong Kong, South China Morning Post, 1956), p. 138. —Trans.

[9] See amulets 394 and 396 in *Numismatique annamite* by D. Lacroix.

[10] J. J. M. de Groot, *The Religious System of China*, vol. 1, p. 55.

The amulets of the Musée Guimet furnish us with the following formulae: *fu shou shuang ch'üan* 福 壽 雙 全, "May your happiness and your longevity both be complete"; *i ch'ang ming fu kuei* 一 長 命 富 貴, "May you have a long life, riches, and honors"; *i shou pi nan shan—fu ju tung hai* 一 壽 比 南 山 · 福 如 東 海, "May your longevity equal that of the Southern Mountains—may your happiness be as vast as the Eastern Sea"; *i shou shan fu hai* 一 壽 山 福 海, "Mountain of longevity, ocean of happiness."[11]

A dish in the Grandidier Collection is ornamented with peaches and citrons of the type known as *fo shou* 佛 手. The *fo shou*, "hands of Buddha," signifies happiness; the peach, *t'ao* 桃, signifies longevity.

A vase in the Musée Guimet presents on two of its faces the phoenix and the dragon, both of which offer happiness: *lung fêng ch'êng hsiang* 龍 鳳 呈 祥, "Dragon and phoenix foretell good fortune." On the other two faces are shown the crane and the deer, both emblems of longevity.

Since the name of the lotus, *lien* 蓮, has the sound of the word *lien* 連, "united," the design of the peach, the bat, and the lotus signifies *lien fu shou* 連 福 壽, "happiness and longevity united."

On a saucer in the Musée Guimet, we find the character *shou* 壽, "longevity"; a bat, whose name has the same sound as the word *fu* 福, "happiness"; and two "cash," or pieces of money. The cash is called *ch'ien* 錢, whose sound has a slight resemblance to that of the word *ch'üan* 全, "complete." Thus *shuang ch'ien* 雙 錢, the "two coins," may be said to resemble, in a way, the sound of the words meaning "both complete." The rebus then may be read: *fu shou shuang ch'üan* 福 壽 雙 全, "May your happiness and your longevity both be complete."

The design on a bowl is composed of a bat, a lotus, and a peach, beneath which is a "double happiness," *shuang hsi* 雙 喜. The bat signifies happiness; the peach, longevity; the double *hsi* indicates that happiness and longevity are double joy. The lotus, *lien* 蓮, having the sound of the word *lien* 連, "united," signifies that the two are united.

Happiness and longevity are not the only desires of the Chinese. To these must be added the wish for a numerous male posterity, the reason for which is found in the idea of the significance of the family that they have developed. To the Chinese, the family has a far greater reality than the individual; secret and powerful ties attach the dead to the living. The dead will not be tranquil in their tombs or on the family altar if they do not have descendants to offer for them the sacrifices prescribed by the rites; and in return, the living will not be happy unless they are surrounded by the beneficent influences of

[11] This amulet is unusual in that the Chinese words are transcribed in *pa-se-pa* characters. It was published in the *Journal asiatique*, January–February, 1897, pp. 148–49, and March–April, 1897, p. 376.

the dead, who mysteriously protect them. If a man does not have a son, no one, after his death, unless he resorts to adoption, can perform the funeral offerings to appease his soul, and in addition, all the ancestors who have died before him will be deprived, through his fault, of the ritual honors they need. This is why Mencius said that the greatest neglect of filial piety is to have no children.[12]

The wish for numerous descendants is therefore frequently expressed. One of the principal classics, *The Book of Odes,* praised T'ai-szu,[13] wife of Emperor Wen, because of her fecundity, she having produced ten sons. It is to this perfect woman, so say the compilers of glossaries, that the allusion is made in the ode[14] that begins with these words: "Locusts, winged tribes, among you union reigns; it is right that you should have a numerous posterity."[15]

An envelope for letter paper represents a young child and, next to him, three words taken from this ode: *yi tzu sun* 宜子孫, "May you have sons and grandsons." In other words, your correspondent wishes that you, like T'ai-szu, may have numerous progeny. Such a wish expressed on an envelope would perhaps seem to us to be indiscreet and serve only to give amusement to the employees of the post office. In China, no one would find it out of the way.

Another verse from *The Book of Odes*[16] celebrates T'ai-szu, saying: *tsê pai szu nan* 則百斯男, "Her sons numbered a hundred."[17] This is not simply a polite exaggeration or poetic license. The commentators explain the phrase by saying that T'ai-szu had, in addition to her other merits, that one so much appreciated by a husband, a Chinese husband, of never being jealous. The other wives of Emperor Wen, then, as well as T'ai-szu, had many sons, of whom T'ai-szu, as the principal wife, was considered to be the mother. A little blue bowl in the Musée Guimet, with its hundred gold points, which ancient design is known by the name "the hundred breasts," recalls the passage from *The Book of Odes* that is found in the above-mentioned verse written on the base: "Her sons numbered a hundred." This object, too, expresses the wish for many descendants.

The pomegranate, we have seen, is a natural symbol of the same idea because of its numerous seeds; a plate filled with these fruits, of porcelain, in the Musée Guimet is

[12] Mencius, book 4, chapter 1, verse 26. Page 313 in Legge's translation. —Trans.

[13] Legge's transliteration of this name is Tae sz and also T'ae-szu. In the Wade-Giles romanization her name would be spelled T'ai-szu. —Trans.

[14] *Che King,* section "Kouo Fong," book 1, ode 5.

[15] Legge's translation of the poem appears in his *Chinese Classics* (London, Oxford University Press, 1960), vol. 4, part 1, ode 5, p. 11. —Trans.

[16] *Che King,* section "Ta Ya," book 1, ode 6.

[17] For Legge's translation of this verse, see *The Chinese Classics,* vol. 4, part 2, ode 6, p. 446. —Trans.

therefore a graceful invitation to take part in the populating of China. The seeds of the pomegranate, and the hundred sons attributed to T'ai-szu, obviously exceed, in a manner most evident, human abilities; in reality, it is necessary to be considerably more moderate. Amulets indicate to us that with which one must be content; they carry the inscription *wu nan erh nü* 五 男 二 女, "May you have five sons and two daughters."[18] Two daughters out of seven children is the proportion in which the Chinese would like to have the feminine element represented in a model family. However, it is not the idea merely of having five sons that is the question. In *The Classic of Three-Word Phrases,* the *San Tzu Ching*[19] 三 字 經, that species of lay catechism stammered out in past years by all little Chinese over the entire empire, is celebrated a personage of the tenth century of our era who, they say, "succeeded in bringing up five sons, all of whom became illustrious": *chiao wu tzu ming chü yang* 教 五 子 名 俱 揚.

On the back of a metal mirror in the Musée Guimet is found the inscription *wu tzu têng k'o* 五 子 登 科, "May your five sons rise to success!"

Finally, there is a design showing five little children quarreling over a crested helmet. They play, you will say, at who will be the general. Not at all; the military are not honored in China. The helmet, *k'uei* 盔, is here the substitute for the word *k'uei* 魁, which designates "the one who places first in an examination." It is therefore a rebus that signifies *wu tzu to k'uei* 五 子 奪 魁, "May you have five sons who will carry off the first place in the examination."

On a vase in the Musée Guimet, we find on one side the five sons called for by the formula of good wishes, on the other side the mythical animal known as the *ch'i lin* 麒 麟, which *The Book of Odes* associates, as we have said, with the noble sons of a duke and which has become a symbol of an illustrious progeny. On the back of the *ch'i lin* is seated a child, and the stereotyped phrase that explains this figure is *ch'i lin sung tzu* 麒 麟 送 子, "May the *ch'i lin* bring you sons."

An embroidery design shows us the same image, but complicated by a play on words; a young child holds in one hand a lotus flower, *lien* 蓮, which has the sound of *lien* 連, "consecutive," and in the other hand a flute with many pipes, *shêng* 笙, which has the sound of *shêng* 生, "to beget." Since the child is mounted on a *ch'i lin,* he is therefore a "noble son," and the rebus may be explained as meaning *lien shêng kuei tzu* 連 生 貴 子, "May you have in succession, one after another, noble sons."

Above the group formed by the child and the *ch'i lin* are shown a Chinese writing brush,

[18] "Five sons and two daughters" is still a common formula for good wishes. —Trans.

[19] The standard English translation of this thirteenth-century primer is that of Herbert A. Giles, first published in Shanghai in 1910. —Trans.

pi 筆; an ingot, *ting* 錠; and a scepter, *ju-i* 如意. By substituting characters with the same sounds, the meaning is *pi ting ju-i* 必定如意, "May everything be according to your wishes."

On another embroidery, the little personage holds in his hand a branch of the cinnamon tree, *kuei* 桂, which has the sound of *kuei* 貴, "noble." He also has a flute, *shêng* 笙. Again, by substituting characters with the same sounds we have the phrase *shêng kuei tzu* 生貴子, "May you have noble sons."

Let us now see how this idea of numerous progeny combines with those we have already studied regarding happiness and longevity. A vase in the Grandidier Collection shows on one side a young lady seated upon a bench; near her a cat, *mao* 貓; and two butterflies, *tieh* 蝶, flying in the air. We recall that *mao* 耄 signifies "the age of ninety years" and *tieh* 耋 "the age of seventy or eighty years."[20] On the other side of the vase, the young lady is standing and is being offered pomegranates. This vase was evidently intended as a gift for a lady and meant to say to her in chivalrous terms: "May you, madame, like the heroines of the fairy tales, live a long time and have many children."

A frequently used motif is that of *wu shih t'ung t'ang* 五世同堂, "five generations in the same hall," showing a Chinese Philemon and Baucis surrounded by their descendants to the fourth generation, longevity and fecundity thus appearing to be the most desirable of all blessings.

Other representations combine the three ideas of happiness, longevity, and numerous progeny. Among these are the vases and embroideries on which are depicted the citrons that are known as the hands of Buddha (happiness), peaches (longevity), and pomegranates (fecundity), or again, the hands of Buddha and bats, peaches, and pomegranates; these symbols express what is called *san to* 三多, the "Three Abundances," this being the origin of that singular expression. An ancient tale found in Chuang Tzu,[21] a writer of the fourth century before our era, relates that the mythical Emperor Yao one day met a man of great wisdom who expressed the wish that the emperor might know three things in abundance: "great longevity, great riches, and many sons."

A vase in the Musée Guimet is "a picture of the Three Abundances," as one can read unmistakably in the title of the verse that is inscribed on it: *san to t'u* 三多圖. Young children are shown assembled, one of whom holds a box of official seals presaging the high dignities to which he will be called; another holds the scepter, *ju-i;* four others read books. These represent the "numerous sons." Beside them is an aged man, with a dispro-

[20] Cf. Burkhardt, *Chinese Creeds and Customs*, p. 111. —Trans.

[21] Cf. *Complete Works of Chuang Tzu*, translated by Burton Watson (New York and London, Columbia University Press, 1968), p. 130. —Trans.

portionately high forehead, who leans on a stick and to whom is offered a peach, indicating that he is the god of longevity. His prodigious cranium also indicates this, being a consequence of great age, since age, in balding the head, makes the forehead appear more vast. Finally, the happy man or the wealthy man, since happiness and wealth are both called *fu* (happiness 福; wealth 富), is here represented as a man of elegant appearance.

Happiness and wealth, longevity, and a numerous posterity make up one of the numerical categories commonly used in China. It is not the only one, however, and it is evident that the idea of the principal happinesses can be analyzed in other ways. Thus we find another series, even better known than the first, of three symbolic personages who are the "Three Immortals of Happiness, Emoluments, and Longevity,"[22] *fu lu shou san hsien* 福祿壽三仙.

This series itself is susceptible of considerable variation. The personage who represents longevity is always easily recognizable because of his extremely high forehead and the peach that he holds in his hand, but the characteristics of the other two are less constant. For instance, *lu* 祿, "emoluments," combines the ideas of wealth and great dignity. Sometimes there is shown a man whose robe of green, *lü* 綠, evokes through a pun the word *lu* 祿, "emoluments," and who carries the tablet, usually of ivory, known as *hu* 笏, which high functionaries held before them at court audiences. Sometimes this Immortal of Emoluments appears as a man in a red robe, color of joy, carrying in his hand the scepter, *ju-i,* which shows that all things conform to his wishes. Finally, the Immortal of Happiness is often represented as a father who carries a child in his arms and has another standing near him. Happiness is thus domestic happiness, which means having sons. But happiness can likewise be riches and satisfaction, so the attributes given him also recall those of the Immortal of Emoluments with his red robe and his *ju-i.*

On a vase in the Musée Guimet, at the right is Longevity, depicted as an aged man with an enormous cranium, who holds a peach and has beside him a crane, *ho* 鶴, symbol of great age. In the center is shown the Immortal of Emoluments, holding a scepter, *ju-i,* and having beside him a deer,[23] whose name, *lu* 鹿, suggests the word *lu* 祿, "emoluments." And finally there is the Immortal of Happiness with his children and a bat, the word for which is *fu* 蝠, suggesting the word *fu* 福, "happiness."

But we do not always find designs as clearly defined as this, and great difficulties are often encountered in trying to explain Chinese symbolism. It is frequently difficult to

[22] Cf. Joseph Hackin, *Asiatic Mythology* (New York, Thomas Y. Crowell, 1963), p. 346. —Trans.

[23] Cf. Stanley Charles Nott, *Voices from the Flowery Kingdom* (New York, Chinese Culture Study Group of America, 1947), p. 191, and Katherine M. Ball, *Decorative Motives of Chinese Art* (London, Bodley Head, and New York, Dodd, Mead & Co., 1927), p. 109. —Trans.

know whether the personage with the children beside him is the Immortal of Happiness in the series of Three Immortals or whether he is the symbol of the wish for numerous progeny in the series of Three Abundances. The scepter, *ju-i,* could be the emblem of the Immortal of Emoluments and that of the Immortal of Happiness. And finally, the deer, *lu,* could signify longevity if one bases the association on ideas that attribute a great age to the deer, while it could signify emoluments if one recalls the pun made on the words *lu,* "deer," and *lu,* "emoluments." Thus an amulet depicting a deer and the character *fu,* "happiness," can be interpreted as expressing the ideas of both happiness and longevity, as well as those of happiness and well-earned honors.

In the enumeration of the Three Immortals, we find introduced, along with the Immortal of Emoluments, a new idea. The Chinese not only desire to live a long time, to be happy, and to have many children; they also wish to become officials. The reasons for this are profound and are found in the teachings of Confucius himself. Here, in a few words, is the theory, which, I need not say, is quite different from actual practice.

What is the greatest good? It is the good of the state. How is it attained? By good government. Ethics are not separate from politics; instead, politics are a development of ethics. What is it that qualifies certain men to govern their peers? It is virtue. The virtuous man, by the power of his example, directs other men and can command them. The emperor is the supreme authority because he possesses the perfect virtue; he delegates a part of his power to the multitude of subordinate functionaries whom he selects from among the most virtuous. But whence is this virtue derived? It results from knowledge. Confucianism is an intellectual system which declares that one errs only through ignorance, and that, if one is sufficiently learned to discern that which is good, one will, of necessity, do that which is good. This knowledge is not that of mathematical or physical science; it is the knowledge of human nature. The man who knows his own heart, who can recognize in it the seeds of virtue that heaven has placed there, cannot do otherwise than develop them.[24]

But where do we acquire this knowledge of the human heart? In the study of ancient literature, left by those perfect sages who were the ornament of humanity in the distant days of the Age of Gold. The examinations, which indicate the men who have best understood the meaning of the classic books, will be, then, the touchstone that designates for the sovereign's choice those who will be able to help him rule in the most effective manner. The scholar is thus the man of virtue above all others, and therefore the one who

[24] According to Mencius, book 2, chapter 6, verses 3 and 4, the "four beginnings" of morality are human-heartedness, *jên* 仁; a sense of right, *i* 義; decorum, *li* 禮; and wisdom, *chih* 智. They are innate and need only to be developed. —Trans.

should be charged with directing the people in the good path. He is the perfect official. This is the reason the official career is held in such honor in China, as is success in the examinations leading to this career.

On an amulet we find the formula *i p'in tang ch'ao* 一品當朝, "May you assist at imperial audiences as an official of the first rank." Above this we find the words *t'ien fu* 天府, "celestial palace," which designates the imperial court. The reverse carries the legend *chuang yüan chi ti* 狀元反第, "With the title of first in the examination of the third degree, may you reach the princely dwelling," which is to say, to dwell in the pomp that in ancient times was reserved for this high grade. Above this, we find the words *ch'an kung* 蟾宮, "palace of the three-legged toad."

What is the three-legged toad doing here? It is a creature consecrated to the moon. Now, everyone knows that in the moon there is a cinnamon tree; since the cinnamon tree blooms in autumn, and it is in autumn that the examination of the second degree is given, it has become associated with success in this examination; to pick a branch of the cinnamon tree in the palace of the toad is a metaphor that signifies "pass with success one's degree."

An amulet in the Musée Guimet illustrates this saying. On one side we see a tree and people who are trying to gather its branches. On the reverse is the inscription *yen yen tan kuei p'iao hsiang tsao—wei erh kao p'an ti i chi* 諺言丹桂飄香早·惟爾高攀第一枝. "A proverb says, 'The wonderful cinnamon tree spreads its perfume in the morning. It is yours to pluck the highest branch.' " In other words, "May you obtain first rank in the examination."

On a vase in the Musée Guimet is shown a carp emerging from the water; before it stands a gate on which we read the words *lung mên* 龍門, "Dragon Gate." The formula that corresponds to this design is *li yü t'iao lung mên* 鯉魚跳龍門, "May the carp leap through the Dragon Gate."[25] It is said that the fish that succeed in getting through the narrow pass of the Dragon Gate in Honan are immediately transformed into dragons.[26] It is a metamorphosis analogous to that of the candidate when he is victorious in the examination. The carp and the gate are merely symbols by which one wishes for the success of a scholar.

Among the highest grades of the state are those of the grand preceptor to the emperor, *t'ai shih* 太師, and the junior preceptor, *hsiao shih* 小師, because these are the officials who are charged with inculcating in the heir apparent to the throne the principles of

[25] Cf. the passage from *San Ch'ih Chi* cited in *P'ei Wên Yün Fou* regarding the expression *lung mên*.
[26] Cf. Anthony Christie, *Chinese Mythology* (Feltham, Middlesex, Hamlyn Publishing Group, 1968), p. 65. —Trans.

virtue. By a play on words, a big lion, *ta shih* 大獅, and a little lion, *hsiao shih* 小獅, express this wish: "May you be, at the court, either the first or the junior official."

A more modest wish is transmitted by the gift of a vase in the form of a jar, *p'ing* 瓶, which contains and seems to produce, *shêng* 生, three miniature halberds, *san chi* 三戟. The explanation of the rebus is the phrase *p'ing shêng san chi* 平陞三級, "May you ascend without obstacle the three degrees in rank."

A piece of letter paper shows a heron, *i lu* 一鷺, among lotuses growing abundantly, *lien shêng* 蓮生. If we write *i lu lien shêng* 一路連陞, we will have the wish, "May you ascend, stage by stage, all the honors."

Finally, since the profession of scholar is the most honored of any, one frequently sees on porcelains certain attributes that characterize it. I will refrain from indicating here the extremely frequent appearance of the four objects the lute, *ch'in* 琴; the board and counters representing chess, *ch'i* 棋; the book, *shu* 書; and the painting, *hua* 畫.

Music and painting are the arts that delight a cultivated mind; the book is the emblem of literary knowledge; and the game of chess or checkers is the diversion of the superior man.[27] One could develop these brief outlines through an infinity of discussions. I will limit myself to quoting this proverb, which opposes the degenerate manners of modern times to the more elevated tastes of the past: "Books, paintings, the lute, and chess; poetry, wine, and flowers; such were the pleasures that, in times past, delighted men of wealth, but now these seven words must all be changed to the following: wood to warm oneself, rice, oil, salt, vinegar, spices, and tea."[28]

We have studied, successively, the two lists of three felicities, the first of which consists of happiness, longevity, and numerous progeny, while the other is that of longevity, emoluments, and joy. There is still a third that is given in classic literature, in one of its most respected texts, "The Great Plan,"[29] which is felt to contain the sum of ancient wisdom. The joys, to the number of five, are listed therein: 1) to live long; 2) to be wealthy; 3) to be tranquil; 4) to love virtue; 5) not to die until after achieving one's destiny. Allusion to this enumeration is frequently made in the design that consists of five bats, that is, five *fu,* or five happinesses. Vases and textiles with this symbol are countless. The Musée Guimet has a saucer on which it is shown in a particularly graceful form: two young children are near a sort of tub inside which one of them holds a bat of which the tip of a

[27] In E. Grandidier's *La céramique chinoise,* no. 69 (plate 25) reproduces a vase on one face of which are seen girls playing lutes and others unrolling a picture-scroll; on the other face, girls read a book and play checkers.

[28] For the Chinese text of this saying, cf. A. H. Smith, *The Proverbs and Common Sayings of the Chinese* (Shanghai, American Presbyterian Press, 1914), p. 71. —Trans.

[29] This is a chapter in the *Shu King.* Cf. Legge, *The Chinese Classics,* vol. 3, part 5, book 4, p. 343.—Trans.

wing can be seen; the other child has possession of a second little creature, which later will join its companion. Three bats still fly about, but it is obvious that they will not be long in being taken, one by one, by the little hands that will thus succeed in capturing these five happinesses. A personage with the demeanor of a bully, who turns as if to admonish the two children, is Chung K'uei 鍾 馗, who, according to legend,[30] is the great destroyer of all the demons and of all malevolent beings. He completes the meaning of the scene by showing that bad influences will be dispelled.

This leads us to speak of a new series of symbols, that of mythological personages. Besides the immortals of happiness, emoluments, and longevity, who are purely personifications of abstract ideas, there exist, in the rich mythology of China, a certain number of legendary heroes who have become symbolic. The following are the principal among them, whom I describe from an arrangement frequently reproduced on tapestry.

We start with the two *ho-ho,* of whom we have already spoken, symbols of concord; one carries his lotus, the other his box. Beside them, Liu Hai plays with his golden cash before the three-legged toad. This toad, *ch'an* 蟾, seems to be the result of a misinterpretation; Liu Hai is, in reality, Liu Hai-ch'an 劉 海 蟾. It was not realized that the word *ch'an* was part of his name, so the words Liu Hai-ch'an were interpreted as signifying "Liu Hai and his toad." The golden cash with which he plays are a symbol of wealth and contentment.[31]

Then come the Eight Immortals, who are recognizable by their attributes:[32]

Li T'ieh-kuai 李 鐵 拐, the beggar with the iron crutch, who carries on his back the gourd from which now and then his soul escapes;

Han Hsiang-tzu 韓 湘 子, with his flute;

Chung-li Ch'üan 鍾 離 權[33] and his fan;

Lan Ts'ai-ho 藍 釆 和, with his basket of flowers;

Lü Tung-pin 呂 洞 賓, his fly-whisk in his hand and his sword on his back;

Chang Kuo-lao 張 果 老,[34] carrying his bizarre musical instrument;

[30] For a detailed account of Chung K'uei see Giles, *A Chinese Biographical Dictionary,* no. 517, p. 207. —Trans.

[31] Pictures of Liu Hai and his toad may be found in du Sartel, *La porcelaine de Chine,* plate 20, and in E. Grandidier, *La céramique chinoise,* plate 7, no. 21.

[32] The Eight Immortals are shown in E. Grandidier, *La céramique chinoise,* plate 7, no. 19, and in W. G. Gulland, *Chinese Porcelain* (second edition, London, Chapman & Hall, 1889), p. 20. Notes on these personages may also be found in *The Chinese Reader's Manual* by William F. Mayers and in *A Chinese Biographical Dictionary* by Herbert A. Giles, but a complete study of the subject has yet to be made.

[33] Chung-li Ch'üan was one of the few Chinese with a double surname. —Trans.

[34] Strictly speaking, the third character, *lao,* is not part of the name of Chang Kuo-lao, although some sources add it. —Trans.

Ts'ao Kuo-chiu 曹 國 舅 and his castanets; and

Ho Hsien-ku 何 仙 姑, the Immortal Virgin, and her long-handled basket.[35]

These eight personages form a basis, in part, for the theory that it is possible to obtain immortality by the mysterious practice of the rites of Tao. What are the reasons that have caused them to be chosen in preference to all others in the great multitude of heroes who appear in Chinese folklore? This is a rather difficult question. Perhaps art itself has played a part in it and because a celebrated painter may once have depicted a particular group of personages, these have become consecrated by a tradition thereafter immutable.

Above the Eight Immortals are the three gods of longevity, emoluments, and happiness. In the air, mounted on a crane, appears Hsi Wang Mu 西 王 母, the Queen Mother of the West,[36] followed by two girls carrying screens. In a boat, two of her faithful servants watch over a tree that bears the peaches of immortality every thousand years, guarding it so that no one may come and steal its precious fruit.

Finally, at the summit, K'uei-hsing, the god of success in literary examinations, brandishes his magic writing brush.

This tableau is actually the depiction of all the happinesses. Parts of it appear on numerous vases, on one of which, in the Grandidier Collection, the Eight Immortals come before the Queen Mother of the West. On another they present themselves before the God of Longevity, who is mounted on a deer and holds peaches in his hand: *pa hsien shang shou* 八 仙 上 壽, "the Eight Immortals before the God of Longevity." In both cases it is the idea of longevity or of immortality, and of the joy that is attached to it, that the artist wished to represent.

Sometimes, in place of the Eight Immortals, their attributes alone are shown. We have, thus, a series of eight objects, sometimes united two by two so as to form four pairs, sometimes separated from one another.

The eight attributes of the immortals are of purely Chinese origin; they are not related to eight other emblems that came from India and were brought in with Buddhism. In India, on the sole of the foot of the Buddha are engraved eight emblems of happy augury, the *ashta mañgala,* [37] which are as follows: the mystic mark on the chest of

[35] Ho Hsien-ku is also shown with a lotus. Cf. C. A. S. Williams, *Encyclopedia of Chinese Symbolism and Art Motives* (New York, Julian Press, Inc., 1960), p. 154. —Trans.

[36] Cf. E. T. Chalmers Werner, *Myths and Legends of China* (London, George G. Harrap & Co., 1922). —Trans.

[37] In Oldfield, *Sketches from Nepal,* vol. 2, p. 267, there is a chart showing the Eight Precious Objects as they are engraved on the sole of the foot of the Buddha. The Buddhist *ashta mañgala* are as follows: 1. çrivatsa, mark on the chest of Vishnu (swastika); 2. *padma,* lotus; 3. *dhvaja,* standard (canopy); 4. *kalaça,* water pot (covered vase); 5. *cāmara,* fly-whisk (yak-tail whisk); 6. *chattra,* parasol (triple parasol); 7. *matsya,* fish (two fish); 8. *çañkha,* conch shell.

Vishnu, the lotus, the standard, the water pot, the yak-tail whisk, the triple parasol, the fish, and the conch. These emblems have entered the art of China, where they are known as the Eight Precious Objects, *pa pao* 八 寶.[38] The original meaning has been so completely lost that the mystic mark of Vishnu has become an enigma even for the Chinese, who sometimes call it the "endless knot" and sometimes the "entrails."

It would be easy to list an even greater number of examples of symbolism in the art of China. It is not a question of isolated cases; it is rather an almost universal rule that decoration in China is symbolic.[39] Once one's attention is turned in that direction, one discovers symbols everywhere. It is an atmosphere in which the Chinese people continuously dwell. But if we have augmented our lists of associations of ideas, of plays upon words, and of mythological personages, we will not be slow to recognize that these new symbols only repeat the several similar wishes that we have deciphered.

This symbolism, then, appears to be basically very simple, composed of certain elementary ideas, but complicated in form, devised by artists with imagination. Then where did this ingenious refinement of expression first develop? It would seem that the very banality of the ideas could have been one of the reasons inciting the Chinese to vary their expression by every possible means. Who of us, on writing the customary New Year letters, has not wished to refresh, in some ingenious way, formulae that become dull when repeated a hundred times?

It is necessary, in addition, to take note of the innate taste of the human spirit for the symbol, whether it be in the inferior form of the rebus or under the more lofty aspect of the association of ideas—source of all poetic images—or of the personification of abstractions, which is the principle of all mythology.

These considerations could explain why the Chinese have varied the means of expressing their thoughts, but they do not show us why these thoughts are repeated identically on many products of their domestic art. In studying the ideas that the Chinese prefer to express through symbols, we start with the idea of happiness. All other concepts which we have passed in review—that of longevity, that of a numerous posterity, that of great official dignities—are only an analysis of the idea of happiness, and are a part of it. One can say then, in a general way, that this symbolism expresses wishes for happiness.

If the Chinese write their good wishes everywhere, it is because they believe in their efficacy. They think that the formula of benediction, like that of malediction, can be

[38] A saucer ornamented with the Eight Precious Objects is reproduced in Grandidier, *La céramique chinoise*, plate 21, no. 30. The wheel of the Law is here substituted for the fly-whisk.

[39] Cf. Burkhardt, *Chinese Creeds and Customs*, especially pp. 119ff. —Trans.

followed by effect, and that in repeating these desires for happiness on clothes and vases that are associated with daily life, one will multiply around oneself the chances for happiness. The belief in the power of the good wish: this is the reason for all these decorations that are themselves only good wishes in disguise.

Apart from that, is this constant preoccupation with happiness not characteristic of the Chinese mind? One who has studied Greek vases could write a volume on their ornament of amorous inscriptions,[40] and this would prove that the sentiment of love played a large part in the life of the Greeks. If one looks at all the mystic flora and fauna that animate the stone lace of our Gothic cathedrals, it is easy to recognize that this decoration is inspired essentially by religious beliefs. And from this it is possible to draw certain conclusions regarding the psychology of ancient Greeks and that of the Middle Ages, respectively. In the same way, on seeing these porcelains, these amulets, and these embroideries, all of which express the desire for happiness, one can conclude that the Chinese mind is as if haunted by this desire, which is, for it, a predominant sentiment.

This happiness—what is it? It is not conceived of as something transcendental; it is life with its worldly advantages, riches, honors, esteem. The Chinese mind is so strongly filled with the love of life that it has always been smitten with the thought of immortality. The emperors of China have searched passionately for the secret of never dying; the indigenous pantheon is almost entirely composed of legendary men who, versed in the magic arts, knew how to escape the law of universal destruction. The wish to have numerous children is no more than another aspect of the desire to survive, since it is the sacrifices offered by the sons that assure the happiness of parents after they die. The family is the form in which the perishable individual becomes immortal. It seems to me that no other people in the world has so intense a feeling regarding the intrinsic value of life.

It is there, I do not hesitate to say, that one can find the profound explanation of the Chinese character. The Chinese, before he knew the foreign religions Buddhism and Christianity, did not trouble himself with the idea of an afterlife, because earthly life as he knew it sufficed, and he demanded nothing more. All the effort of his will was concentrated on a code of ethics, Confucianism, of which the obligations and sanctions were purely human. Life itself was its own reason for being.

These considerations in connection with some decorations on vases and hangings could appear a bit ambitious; but is it not precisely in this imagery, which is the work of anonymous artists conforming to the taste of the people, is it not in this popular art that are

[40] Wilhelm Klein, *Die griechen Vasen und Lieblingsinschriften* (second edition, Leipzig, 1898).

shown most clearly the elementary tendencies that are the basis of a nation's mentality? These porcelains and embroideries are not mere fantasies destined only to charm the eye; rather, I believe that I can hear emanating from them millions upon millions of voices, repeating endlessly the concept of human destiny devised by an entire race.

DRAWINGS AND COMMENTARIES

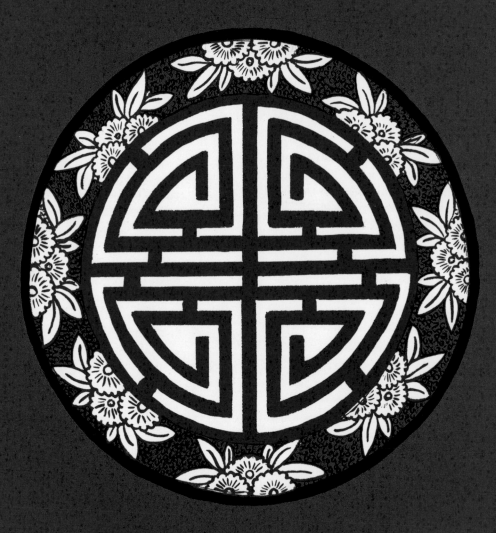

SHOU

The CHARACTER MEANING "LONGEVITY," *shou,* is one of the oldest and most frequently used of the symbols of long life. It has countless variations in design, some so stylized as to be almost unrecognizable except to calligraphers who themselves are adept in the use of the brush, know its limitations and possibilities, and can detect the modifications that copyists or artisans have made over the centuries. The following seventeen drawings show some of these myriad forms.

The Chinese say that there are a hundred ways of writing *shou,* but "one hundred" in such contexts simply means "many." It commonly appears woven into silk, worked in embroidery, carved in jade, and painted on porcelain, to mention only a few media. Sometimes swastikas are incorporated in the design of the character, in which case the wish expressed is increased ten-thousandfold, or "many times," since the swastika is used by the Chinese as a substitute for the character *wan* 萬, meaning "myriad," "ten thousand," or simply "many."

The idea of longevity is generally accepted as the most commonly expressed wish in Chinese popular art, and frequently it is used together with other motifs that signify the blessings of happiness and long life.

The geometrical borders shown in many of the drawings are variations of the ancient cloud-and-thunder, or meander, pattern. In an agricultural society, clouds bringing needed moisture from the skies were an important phenomenon of nature, and their depiction as an ornamental design implied hope for beneficent rain so that the crops would flourish and the people prosper.

For further discussion, see pages 22, 23, and 24.

Suggested references:
Ball, Katherine M.: *Decorative Motives of Chinese Art,* p. 258 (swastika)
Chalmers, John: *An Account of the Structure of Chinese Characters,* para. 293
Weiger, Léon: *Chinese Characters,* p. 313
Wilder, G. D., and J. H. Ingram: *Analysis of Chinese Characters,* p. 153
Williams, C. A. S.: *Encyclopedia of Chinese Symbolism and Art Motives,* p. 116 (meander),
 p. 377 (swastika)

1

THE CHARACTER IN THE ROUND MEDALLION is a commonly used form of *shou* and was taken from the design on a brass bowl. The other designs depict a few of the countless variations of this character that have been developed. They were found on various types of textiles, embroidery, and porcelains.

2

THE ROUND MEDALLION in the center of the top row of figures is a written form of *shou,* found on a brass bowl. The remaining designs are stylized versions of the character and were found on textiles, embroidery, and porcelains, with the exception of the central figure in the second row from the top. This is from a brass piece such as would be used as a hanger or as a door handle.

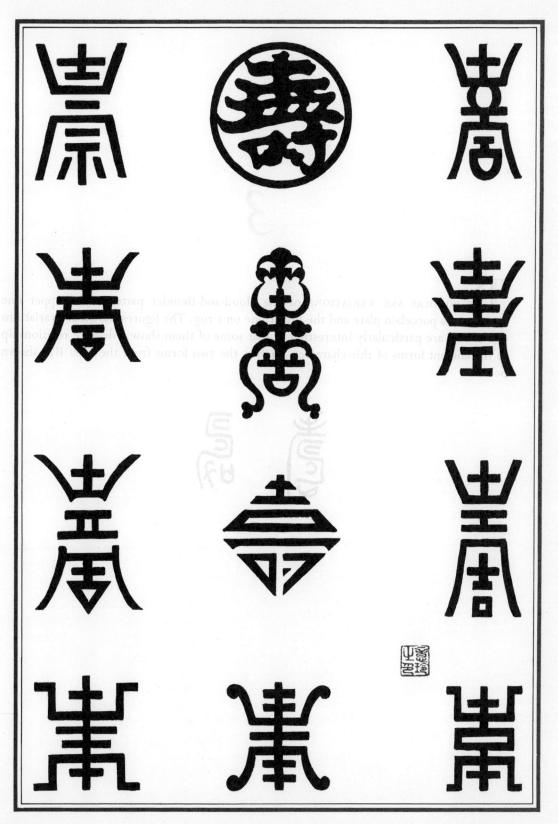

3

THE BORDERS ARE VARIATIONS of the cloud-and-thunder pattern. The upper one appears on a porcelain plate and the lower one on a rug. The figures shown are variations of *shou* and are particularly interesting in that some of them show a definite relationship to the ancient forms of this character, such as the two forms from the *Shou Wên* shown below.

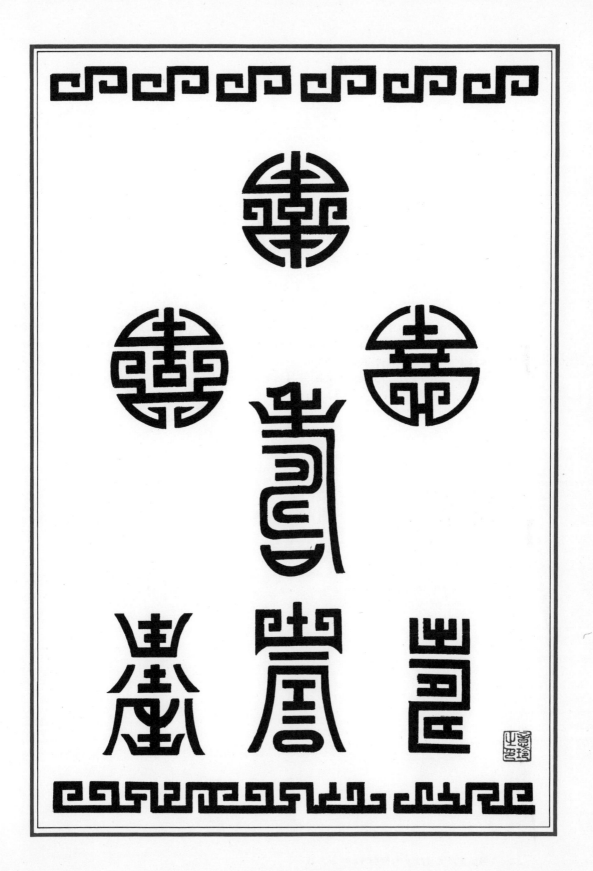

4

T HE ENTIRE UPPER BORDER is from a brass *ku* and depicts a form of the cloud-and-thunder pattern, as well as a variation of *shou*. The three versions of *shou* below this are from textiles and are also found as decoration in other media. The cloud-and-thunder meander that forms the lower border is from a porcelain plate.

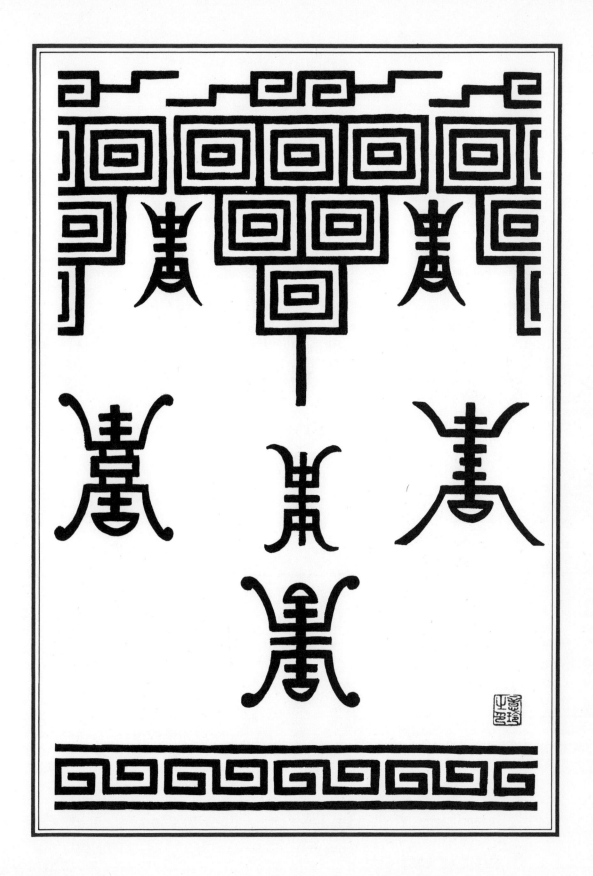

5

THE LOWER BORDER is a combination of two variations of *shou* found on a modern Chinese greeting card. In the square medallion is a form of *shou* surrounded by a border of peach blossoms. This is from a brass trivet. The three round versions of *shou* are taken from designs woven into pieces of damask. The three oblong variations are also from textiles.

Suggested reference:
 Williams, C. A. S.: *Encyclopedia of Chinese Symbolism and Art Motives*, pp. 312–13

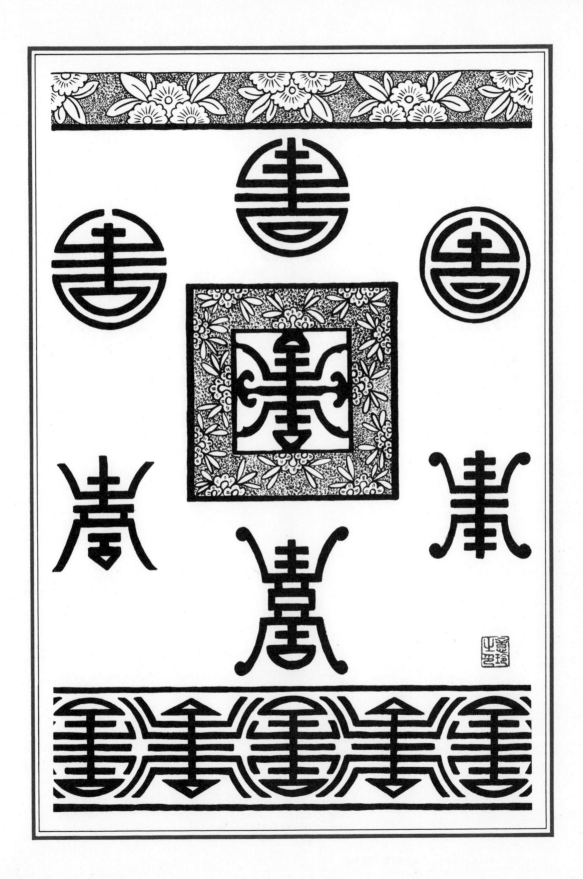

6

Of the round forms of *shou* depicted, the center medallion is from a brass trivet and the other three designs are from pieces of damask. The borders depict variations of the scroll pattern, whose origin and meaning are uncertain.

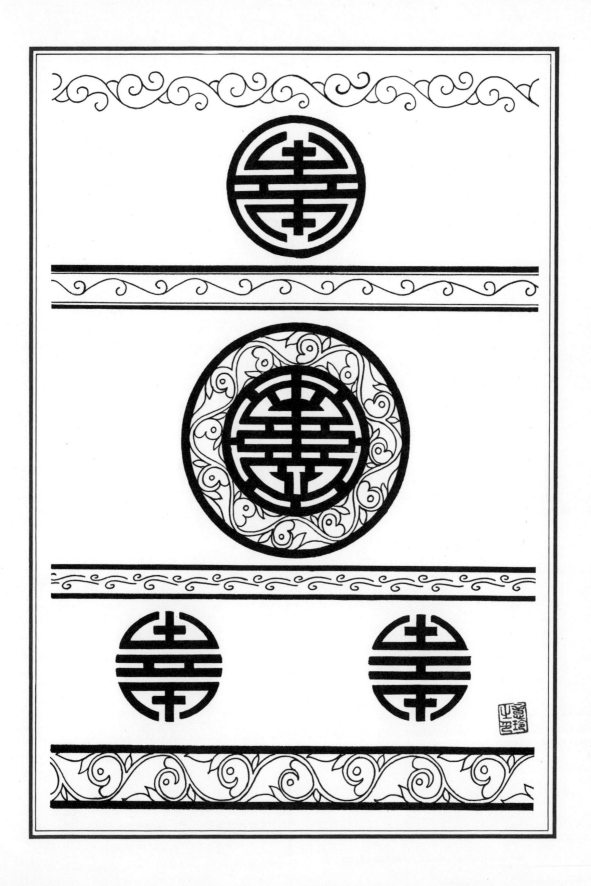

7

SHOWN OPPOSITE ARE THREE VARIATIONS of the *shou*. The small design on the left is from a piece of embroidery; the other two are from designs woven into silk. The medallion in the lower right-hand corner is from a small embroidered mat, and the other three are from enameled plates. These show various forms of the peony, *mu tan hua* 牡丹花, which is said to convey the idea of riches and honors.

Suggested reference:
Williams, C. A. S.: *Encyclopedia of Chinese Symbolism and Art Motives,* p. 317

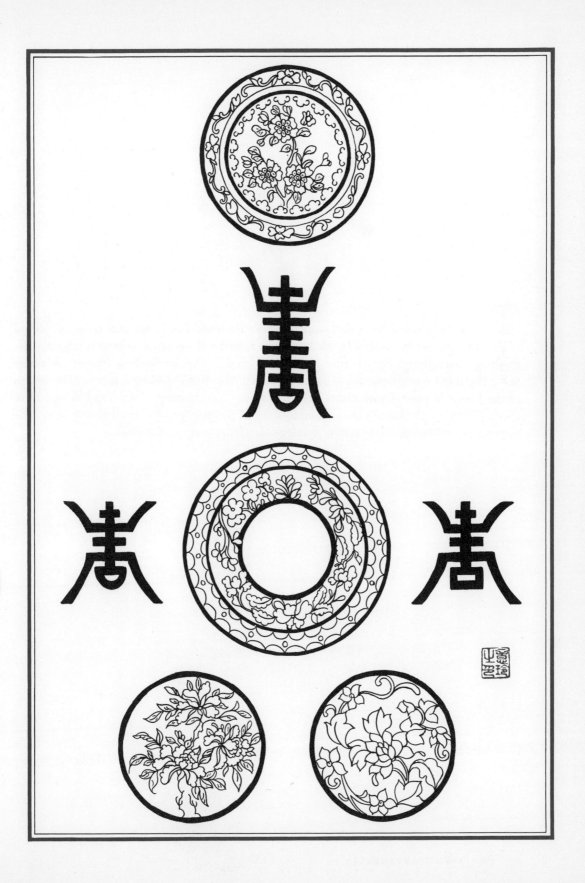

8

THE UPPER BORDER is a design of *ju-i* heads, sometimes referred to as a "cloud collar." It appears in various forms as a decorative band on vases, where it suggests the meaning "May things be according to your wishes." This example is from a cloisonné vase. The floral medallions are of peonies and are also from cloisonné pieces. The design of the lower border is sometimes referred to as "overlapping scales" and is typical of designs used on cloisonné. This example is from the border of a small round box. The round *shou,* appearing here in four versions, are from pieces of damask.

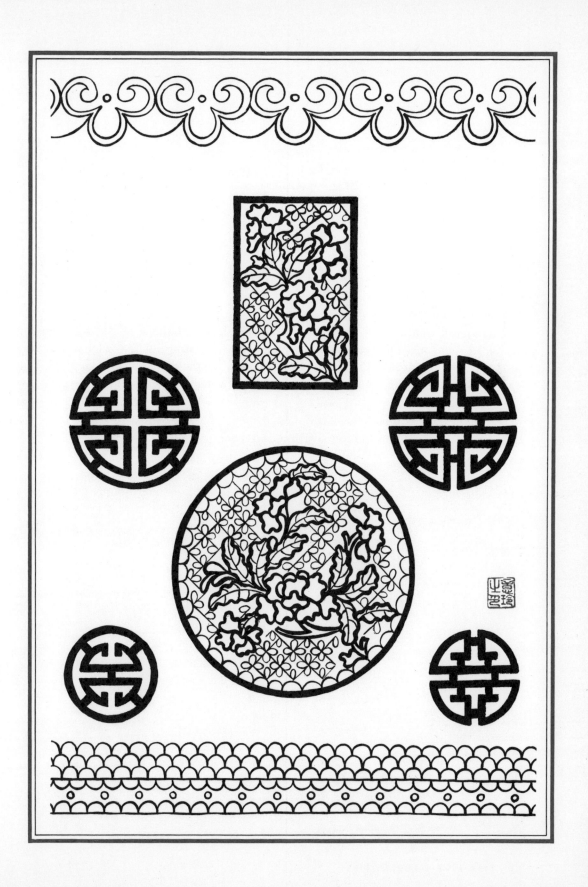

9

The upper border and the large medallion show variations of the peony design. The small round medallion depicts a peach blossom, indicating a wish for longevity, with the symbolism repeated in the narrow floral border. All the designs are decorations from a brass teapot, the small medallion reproducing the motif on the lid of the pot.

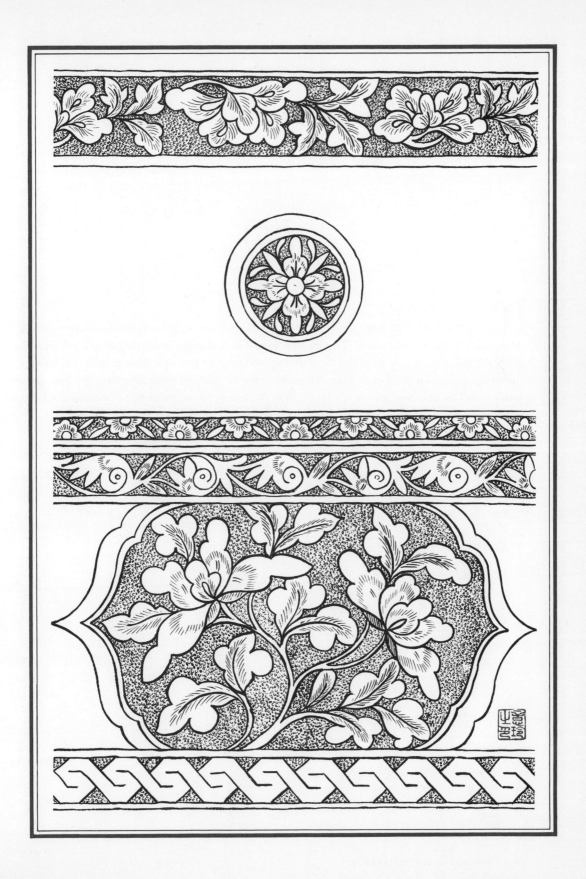

10

T HE BORDER AT THE TOP of the drawing is of peaches and peach blossoms, suggesting wishes for a happy marriage. The center medallion depicts an arrangement of peonies with a border of *ju-i* heads, the flowers symbolizing riches and honors and the border, "according to your wishes." This design appears on a small cloisonné saucer. The three borders below this medallion are taken from a pewter sweetmeat box, one border being used on each of its three sections. The design includes bats, peaches, and peonies, the wishes suggested being happiness, longevity, and opulence, respectively.

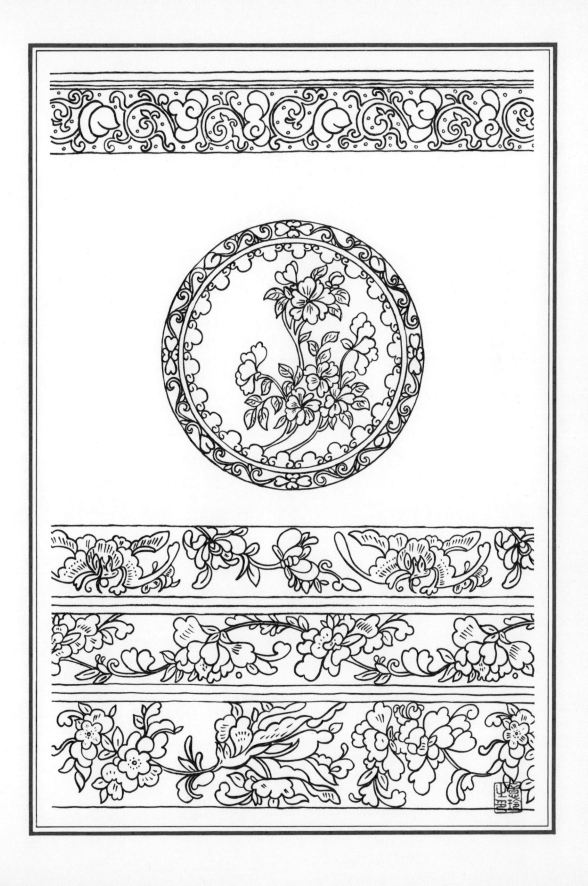

11

THE UPPER AND LOWER BORDERS show the cloud-and-thunder meander that appears so frequently on articles of everyday use. The round figures are variations of *shou*. The central medallion with its border of peach blossoms is from the design on a brass trivet.

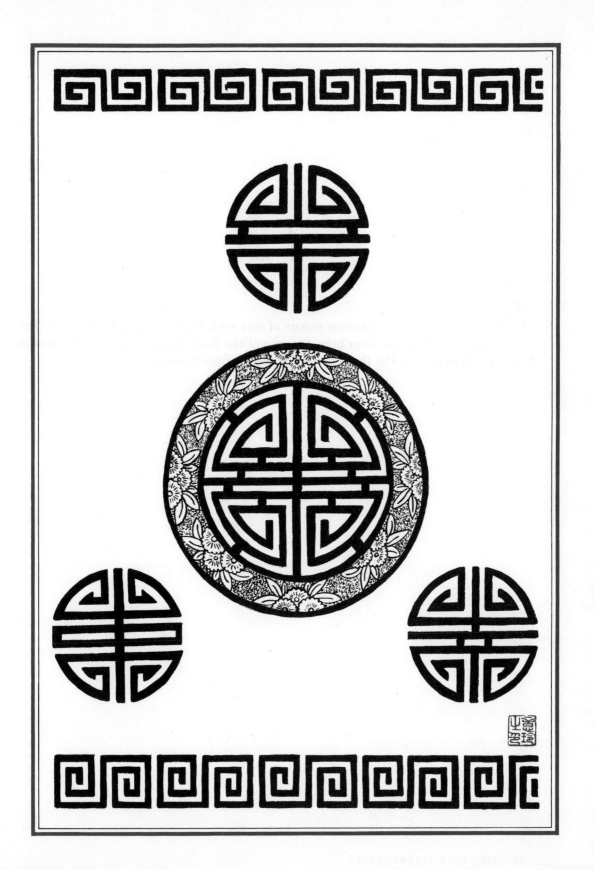

12

SHOWN OPPOSITE ARE VARIOUS FORMS of *shou* with borders of peach blossoms. The hexagonal medallions are from brass trivets and the floral borders from the decoration on other brass pieces. The three central motifs are from textiles.

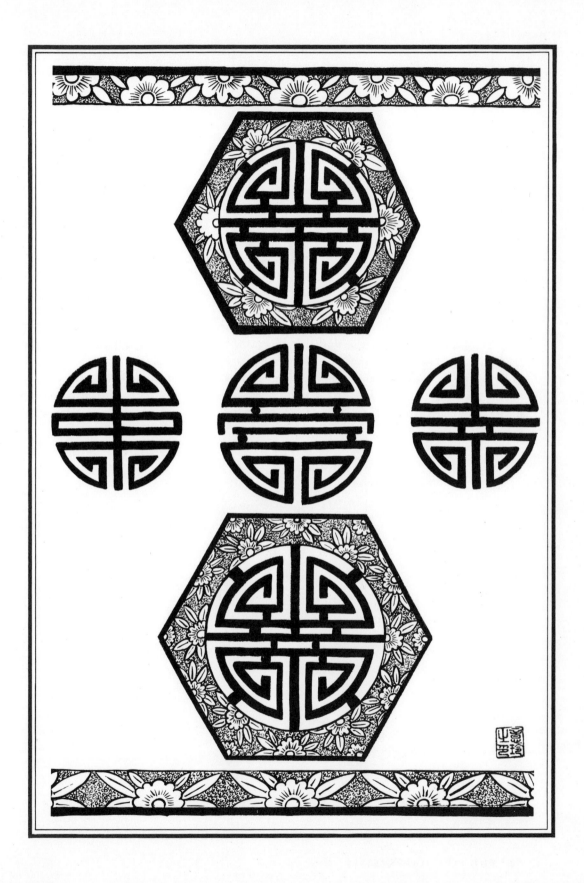

13

These variations of the character *shou* incorporate the swastika in their design. Its presence indicates that the wish for longevity expressed by *shou* is multiplied ten-thousandfold. The central medallion shows the use of interlocked swastikas as a background for a floral design, and its border is an example of the ancient "overlapping scales" pattern. This design is from the top of a small cloisonné box. The border at the bottom of the drawing is from a lacquer table.

14

THIS DESIGN, TAKEN FROM THE TOP and sides of a small cloisonné box, again uses interlocking swastikas as the background of a floral pattern, multiplying by ten thousand the wish for opulence expressed in the peony motif. The border of overlapping scales is frequently used on cloisonné pieces.

15

SHOWN ARE VARIATIONS of *shou* incorporating the swastika. The motifs shown are from textiles, with the exception of the design immediately beneath the upper border, which is from a brass piece of the type used as a drawer or door handle.

16

THE SWASTIKA WITH ITS DECORATION of flying ribbons (discussed in commentary 45), the borders, and the two round *shou* are from textiles. The pattern of swastikas forming a diaper design is from a small cinnabar box.

17

THE LARGE ROUND MEDALLION (a variation of *shou*), the corners, and the section of a background design sometimes known as "interlocking Ts" are from carpets. The border in the center is a version of the cloud-and-thunder meander that is said to represent the dragon. It is taken from the design on a porcelain plate.

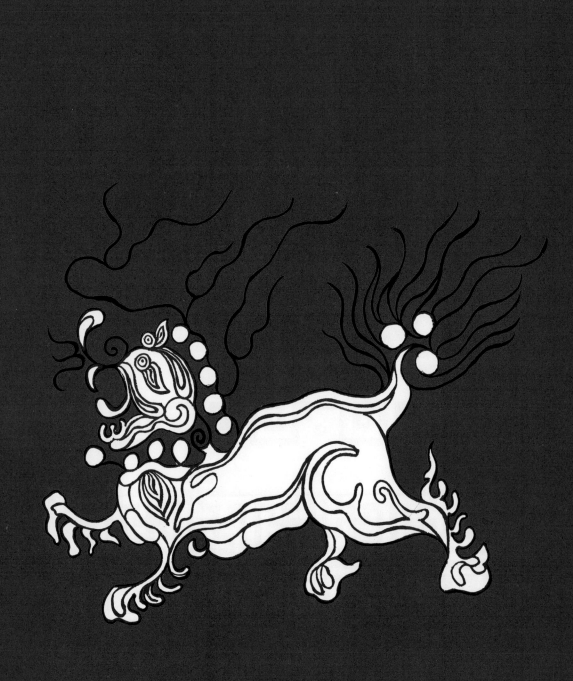

CH'I LIN

THE MYTHICAL ANIMAL *ch'i lin,* sometimes called a chimera or a unicorn in English, is discussed on pages 17 and 26. The following drawing shows a typical representation.

Suggested references:
Barondes, R. de Rohan: *China, Lore, Legend and Lyrics,* p. 49
Burkhardt, V. R.: *Chinese Creeds and Customs*
Christie, Anthony: *Chinese Mythology*
Ferguson, John C.: *The Mythology of All Races,* vol. 8, p. 98
Nott, Stanley Charles: *Chinese Jade Throughout the Ages*
Sowerby, Arthur de Carle: *Nature in Chinese Art*
Whitlock, Herbert P., and Martin L. Ehrmann: *The Story of Jade*
Willetts, William: *Chinese Art*
Williams, C. A. S.: *Encyclopedia of Chinese Symbolism and Art Motives*

18

THE ANIMAL MOTIF is a *ch'i lin*, one of a pair embroidered in gold on a red satin panel. The variations of *shou* and swastikas are from textiles.

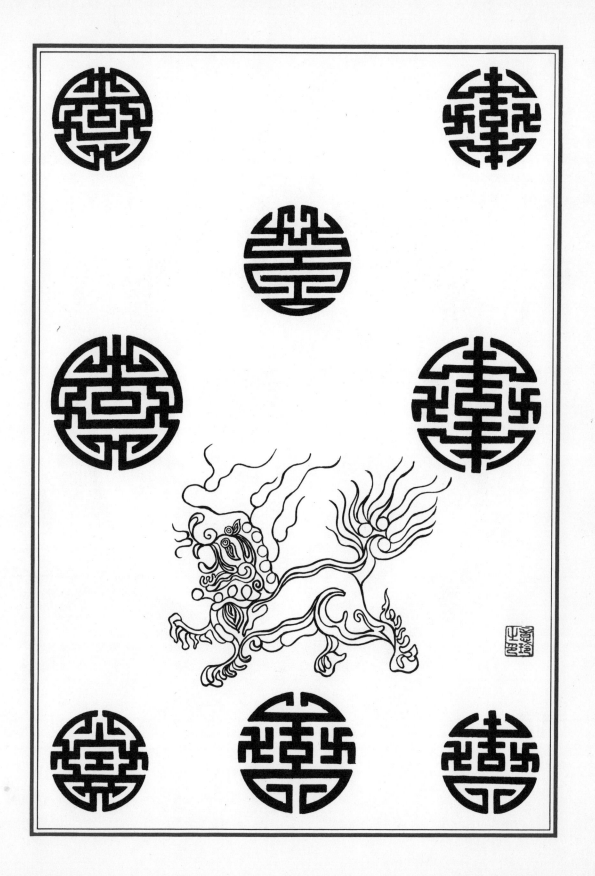

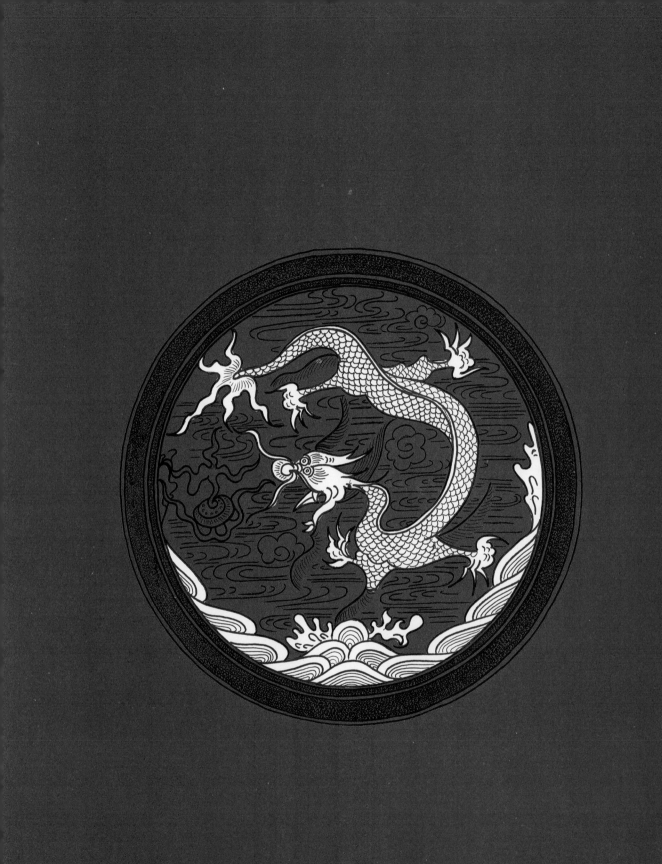

龍

LUNG

THE CHINESE DRAGON, *lung*, is regarded as a beneficent being that in relatively recent times became the emblem of the emperor, who alone had the privilege of using as ornamentation on robes, utensils, and banners the design of a dragon with five claws. Lesser princes could also use a dragon design, but with only three or four claws. There are theories that the number five—perhaps the most common of the numeral categories so frequently used by the Chinese—may symbolize the five happinesses, the five constant virtues, or the five great leaders of antiquity.

The *lung* is discussed on pages 17–18, 21, and 24. The following seven drawings show various depictions of the dragon and related symbolic motifs.

Suggested references:

Ball, Katherine M.: *Decorative Motives of Chinese Art*
Barondes, R. de Rohan: *China, Lore, Legend and Lyrics,* pp. 37–40
Burkhardt, V. R.: *Chinese Creeds and Customs*
Burling, Judith, and Arthur Hart: *Chinese Art*
Christie, Anthony: *Chinese Mythology*
Grousset, René: *Chinese Art and Culture*
Hayes, L. Newton: *The Chinese Dragon*
Laufer, Berthold: *Jade*
Mathews, R. H.: *Chinese-English Dictionary,* p. 604
Mayers, W. F.: *The Chinese Reader's Manual,* pp. 332–41
Nott, Stanley Charles: *Chinese Jade Throughout the Ages*
Silcock, Arnold: *Introduction to Chinese Art and History*
Sowerby, Arthur de Carle: *Nature in Chinese Art*
Strong, Hilda Arthurs: *A Sketch of Chinese Arts and Crafts*
Tredwell, Winifred Reed: *Chinese Art Motives Interpreted*
Tun Li-ch'en: *Annual Customs and Festivals in Peking*
Whitlock, Herbert P., and Martin L. Ehrmann: *The Story of Jade*
Willetts, William: *Chinese Art*
Williams, C. A. S.: *Encyclopedia of Chinese Symbolism and Art Motives*

19

T HESE DRAGONS, FROM DESIGNS on a nest of lacquered tables, show the attributes usually given the *lung*. Dragons are supposed to travel about upon the clouds, and it is a common belief that clouds spring from dragons. It is also said that as long as the dragon has moisture in the form of water or clouds surrounding its body, it retains its marvelous powers, but that if this moisture disappears, the creature becomes powerless and dies.

Suggested reference:
Hayes, L. Newton: *The Chinese Dragon*, pp. 27–28

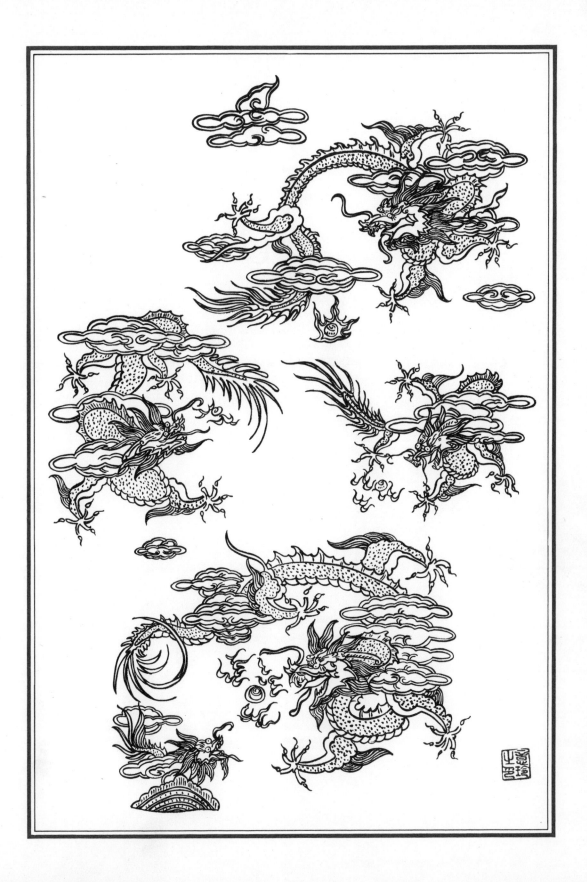

20

ALL THESE DESIGNS ARE TAKEN from inside a brass basin. If we refer to page 30, we can imagine an aspiring scholar looking at them as he washes his face, and thinking that even as the carp succeed in leaping through the Dragon Gate to become dragons, so will he overcome the difficulties of the examinations and succeed in becoming an official. A basin like this would have been a fitting present to give a candidate for the examinations, suggesting as it does the wish for his success.

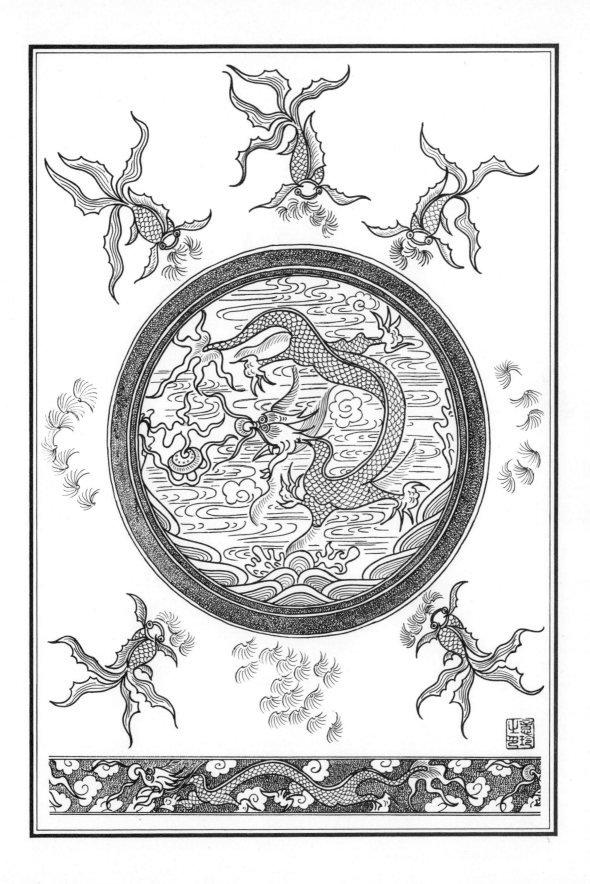

21

Shown opposite are dragon and cloud designs from the decoration on a brass box. At the autumnal equinox the dragons are said to descend into the sea, where they hibernate for six months in gorgeous palaces on the ocean floor, ascending again into the clouds at the vernal equinox.

Suggested reference:
Hayes, L. Newton: *The Chinese Dragon,* p. 30

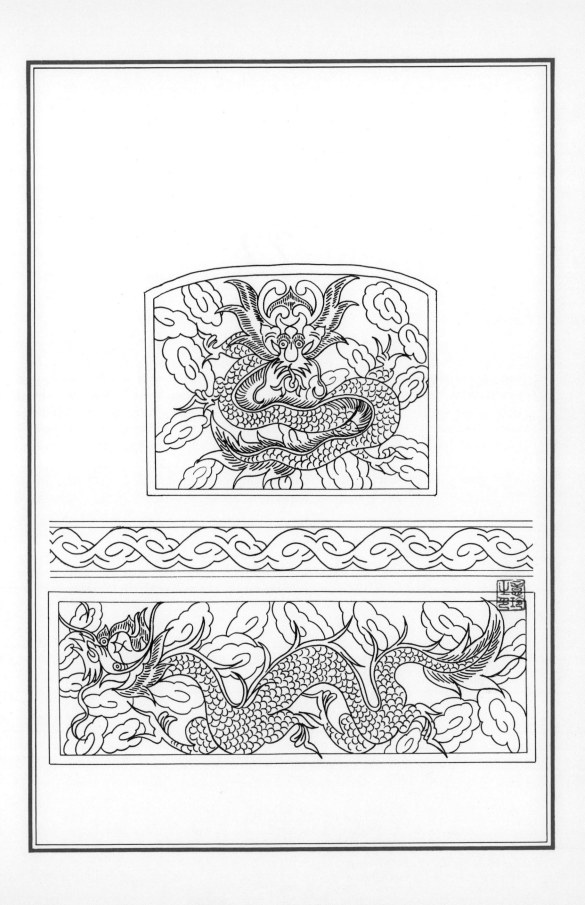

22

THE DRAGON OFTEN APPEARS in conjunction with three peaks surrounded by waves. These are said to represent the *san hsien shan* 三仙山, or Three Mystic Peaks—the Chinese Isles of the Blest, inhabited by immortals. Ssu-ma Ch'ien, in his *Historical Records,* says of these three peaks that they are not far distant from the mainland, but always as boats approach, winds spring up and drive them off. Many voyagers have seen them from a distance, like clouds on the horizon, but as they neared them everything vanished. A few travelers have succeeded in landing on them, returning home with tales of strange birds and quadrupeds of gold and silver. The inhabitants partake of a mysterious plant growing only on these isles and imparting immortality to all who eat it. The motifs in this drawing are from a red satin panel, on which they are embroidered in gold thread.

Suggested references:
 Li Ch'iao-p'ing: "The Chemical Arts of Old China," pp. 6, 9
 Williams, C. A. S.: *Encyclopedia of Chinese Symbolism and Art Motives,* p. 231

23

THIS MOUNTAIN AND WAVE DESIGN, from a piece of tapestry, depicts the isles of the immortals discussed in commentary 22. The round *shou* in the center is from a porcelain plate.

24

Two DRAGONS WITH CLOUDS, waves, and "ball" (see pages 17–18) form the border surrounding a frequently used variation of *shou*. This design is from a large brass bowl. At the top of the page is a detailed drawing of a "ball" with its accompanying flames.

Suggested reference:
> Williams, C. A. S.: *Encyclopedia of Chinese Symbolism and Art Motives,* p. 137 (dragons' ball)

25

THIS DESIGN IS SIMILAR to that of drawing 24 except that the dragons surround the character known as *shuang hsi,* or "double happiness" (see page 22). This design forms the decoration of a large brass bowl. The border at the bottom of the page is taken from a piece of embroidery and is a variation of waves surrounding the three mountain peaks that are said to be the habitation of immortals.

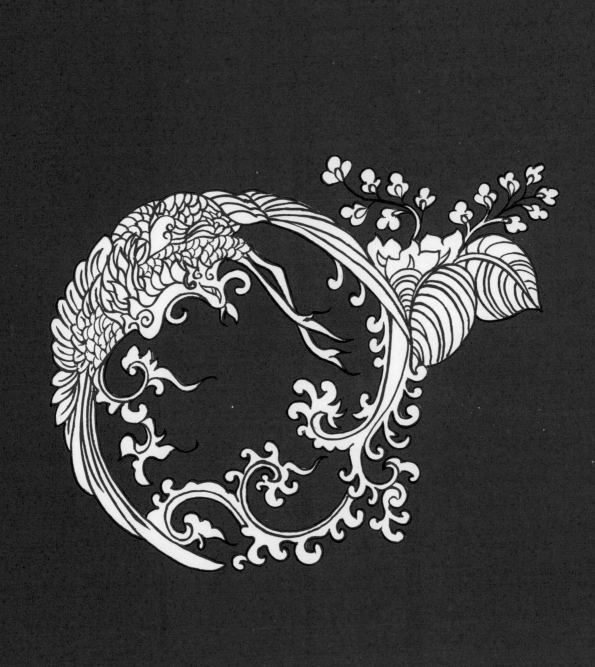

FENG HUANG

THE FÊNG HUANG, A FABULOUS BIRD usually called "phoenix" in English, is discussed on pages 21 and 24. The following three drawings show typical depictions in art.

Suggested references:
Barondes, R. de Rohan: *China, Lore, Legend and Lyrics*, p. 45
Burkhardt, V. R.: *Chinese Creeds and Customs*
Ferguson, John C.: *The Mythology of All Races*, vol. 8, pp. 21, 98–99
Nott, Stanley Charles: *Chinese Jade Throughout the Ages*
Sowerby, Arthur de Carle: *Nature in Chinese Art*
Tredwell, Winifred Reed: *Chinese Art Motives Interpreted*
Willetts, William: *Chinese Art*
Williams, C. A. S.: *Encyclopedia of Chinese Symbolism and Art Motives*

26

THE FÊNG HUANG, OR PHOENIX, MOTIFS shown here are taken from the design on a blue and white porcelain flower pot.

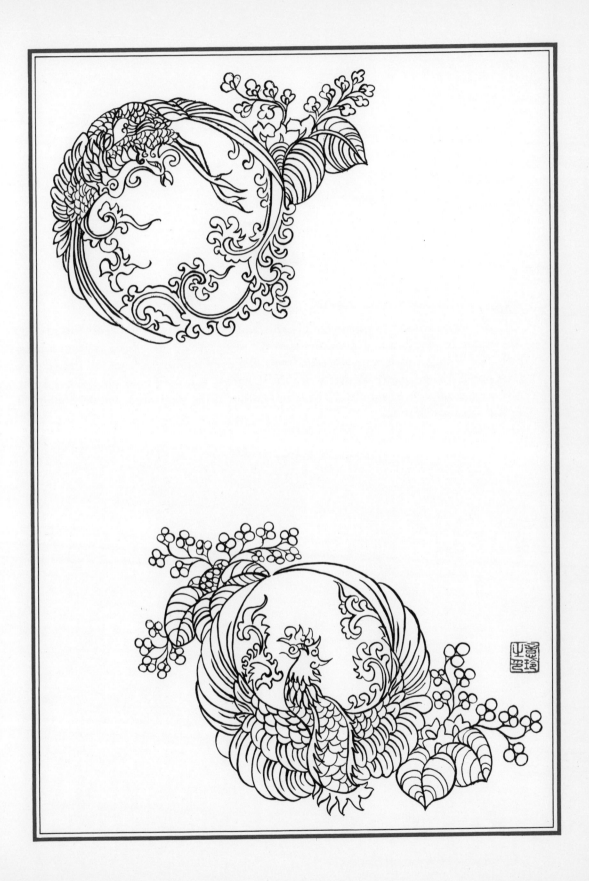

27

THE LOWER BORDER, depicting a phoenix and a dragon, is from a small brass bowl. Above this is a version of a meander from the same bowl. The dragon is from a brass bell. The "ball," which is usually found with the dragon motif, is from the design on a brass bowl. The geometric design above the dragon is said itself to symbolize a dragon; it is taken from a porcelain plate. The scroll border at the top is from the decoration on a small brass candlestick.

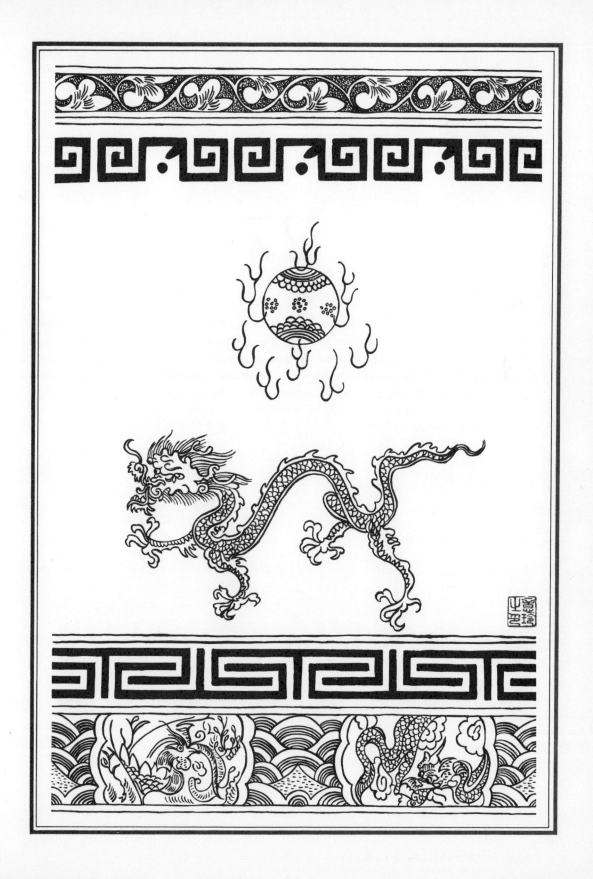

28

THE DRAGON AND PHOENIX are taken from a small porcelain plate set in pewter. The border at the bottom of the drawing appears around the rim of the plate, framing the design. This combination of the dragon and phoenix is popularly used on dishes, boxes, and other objects connected with weddings. Betrothal certificates are known as "dragon-phoenix papers," and wedding cakes are called "dragon-phoenix cakes."

Suggested reference:
Hayes, L. Newton: *The Chinese Dragon*, p. 36

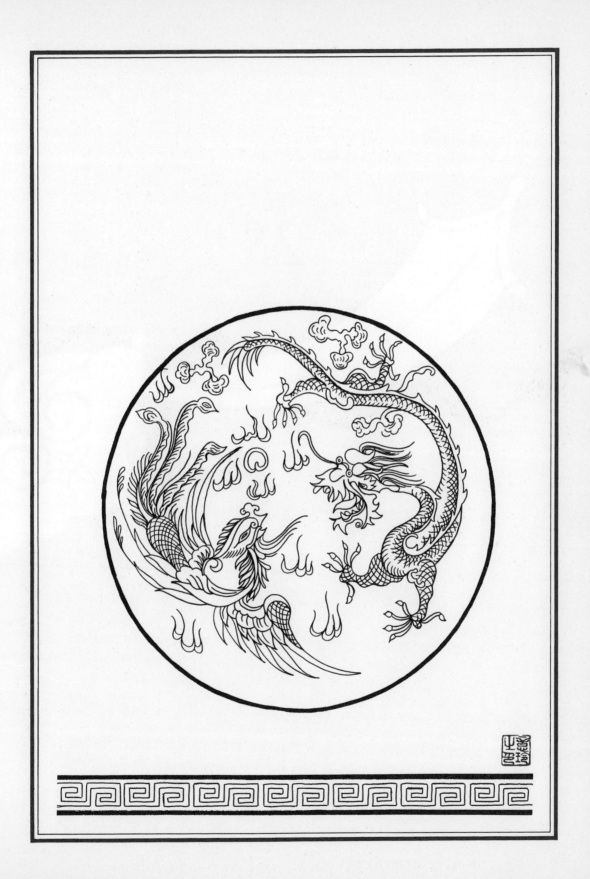

如意

JU-I

THE VARIATIONS OF THE DESIGN known as *ju-i* shown in the following four drawings incorporate conventionalized forms of the mystic fungus to which this term is applied, and which conveys the implication of power, fortune, and the granting of every good wish. Scepters with heads in this form were presented by the emperor as a mark of favor to members of the court who had gained his approval.

The origin of this symbol is obscure. According to one theory, it was derived from the shape of a magic fungus that was said to have powers to "point the way," in other words, to endow its eaters with the power of prophecy. The *ju-i* is discussed on pages 19 and 22.

Suggested references:
Giles, Herbert A.: *A History of Chinese Pictorial Art,* pp. 158–59
Goette, John: *Jade Lore,* p. 214
Laufer, Berthold: *Jade*
Osgood, Cornelius: *Blue and White Chinese Porcelains,* p. 15
Pope-Hennessy, Una: *Early Chinese Jades,* p. 77
Sowerby, Arthur de Carle: *Nature in Chinese Art*
Williams, C. A. S.: *Encyclopedia of Chinese Symbolism and Art Motives,* p. 236

29

Shown are three variations of *shou*, one of which is surrounded by versions of the *ju-i* head. These add the meaning "according to one's wishes" to the desire for longevity signified by *shou*. The upper and lower borders are variations of the *ju-i* motif that were found on cloisonné vases. The *shou* motifs are from textiles.

30

THE JU-I MOTIF IS HERE COMBINED with peach blossoms and is decorated with a swastika and flying ribbons, the whole conveying wishes for happiness and longevity "as you wish." (The significance of the ribbons is discussed in commentary 45.) The upper and lower borders are from small cloisonné boxes, and the wish for opulence expressed by the design of peonies is multiplied ten-thousandfold by the background of interlaced swastikas.

31

THE BORDERS DEPICT VARIOUS TYPES of *ju-i* head designs found on porcelain vases. These are sometimes known as "cloud collars." The *ju-i* motif in the center carries the added value of the swastika and is surrounded by flying ribbons (discussed in commentary 45).

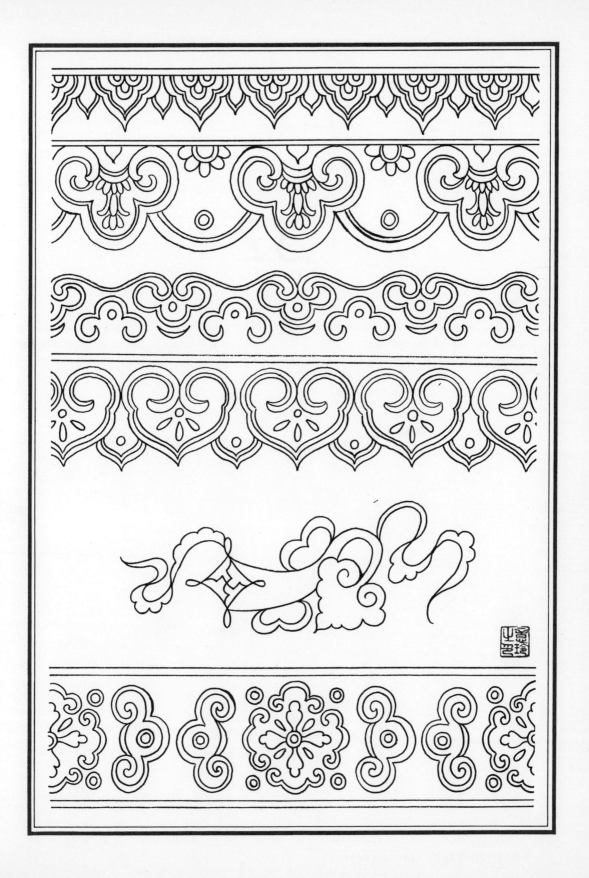

32

Shown here are variations of the *ju-i* head design such as appear on porcelain. The *ju-i* motif in the center carries flying ribbons indicating its revered status (see commentary 45).

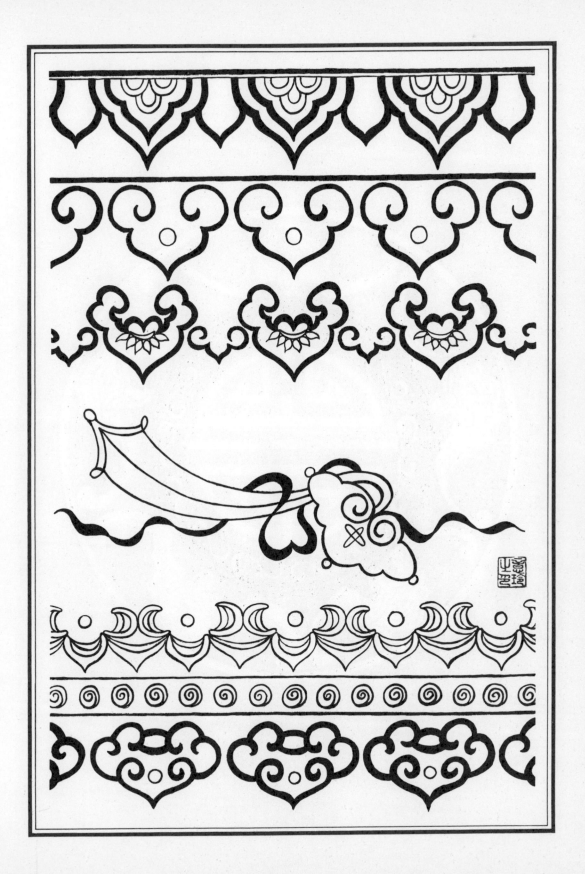

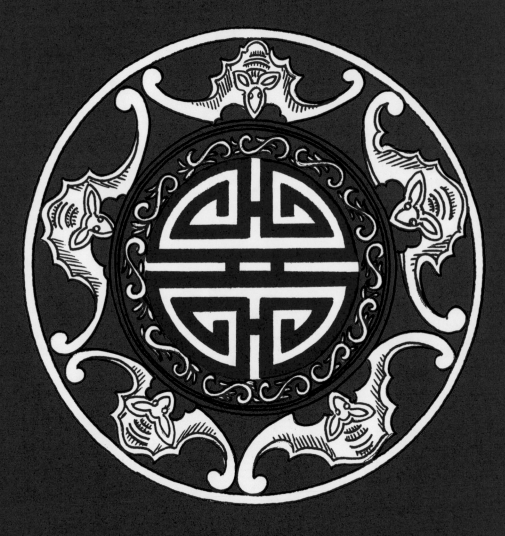

FU

THE FOLLOWING SIX DRAWINGS show some of the variations of the character *fu*, "happiness," and related motifs. It often appears with or is replaced by fancifully designed bats (also called *fu*), as well as other auspicious symbols. *Fu* is discussed on pages 20–21.

Suggested references:
 Ball, Katherine M.: *Decorative Motives of Chinese Art,* p. 258
 Karlgren, Bernhard: *Analytic Dictionary of Chinese and Sino-Japanese*
 Mathews, R. H.: *Chinese-English Dictionary*
 Nott, Stanley Charles: *Voices from the Flowery Kingdom,* p. 184
 Sowerby, Arthur de Carle: *Nature in Chinese Art*
 Wilder, G. D., and J. H. Ingram: *Analysis of Chinese Characters*
 Williams, C. A. S.: *Encyclopedia of Chinese Symbolism and Art Motives,* p. 33 (bat)

33

THIS IS A VERSION of the round *shou* surrounded by the five bats, or five *fu,* that is, the five happinesses (see page 31). This design is the central motif of a porcelain plate; the bats are in red, the color of joy. The border below is taken from the inside rim of a blue and white tea bowl.

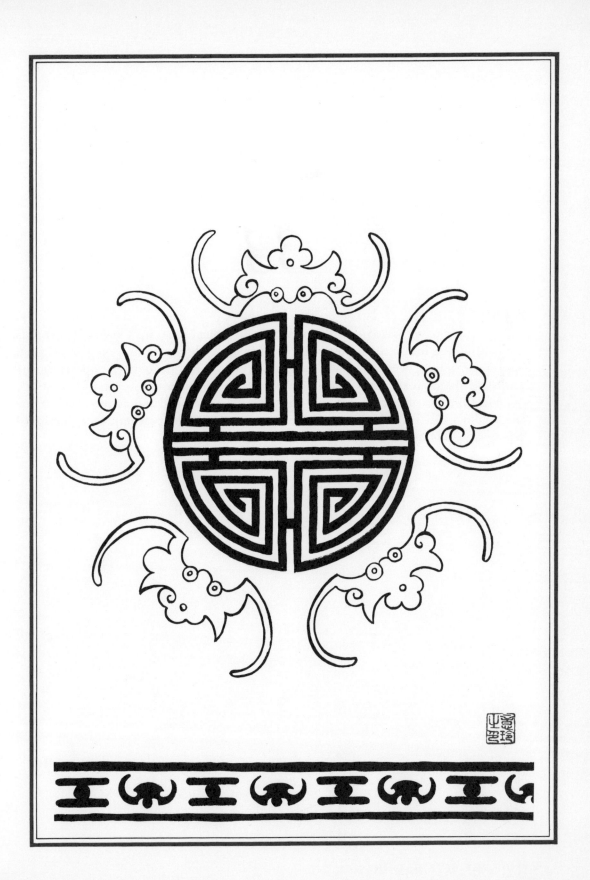

34

THE CENTRAL MEDALLION, with its design of a round *shou* surrounded by five bats symbolizing the five *fu,* or happinesses, is taken from the decoration on a brass gong. The upper border, with a repeated design of two peaches (longevity), appears on the four sides of a small brass box. The lower border, showing a bat, peaches, and swastikas, is taken from the decoration inside a blue and white tea bowl and conveys wishes that the beholder may enjoy happiness (the bat) and long life (the peaches), each multiplied ten-thousandfold by the swastikas.

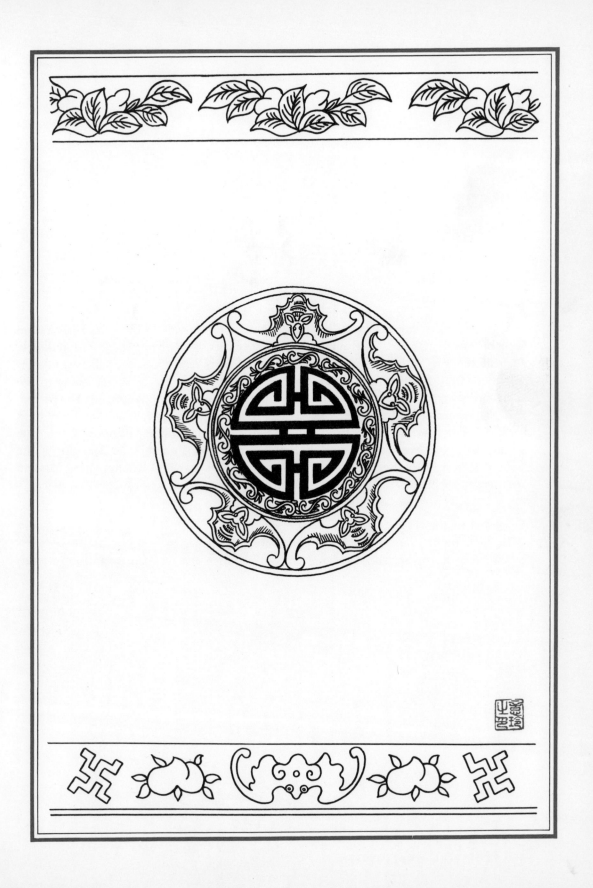

35

THESE DESIGNS ARE TAKEN from inside a metal washbasin. In the center is a round form of *shou*, "longevity." Surrounding this are five bats, symbolizing the five happinesses. Outside this ring of bats is a scroll border of indeterminate meaning, and beyond it is a border of *ju-i* heads, indicating that all these good wishes are to be according to the individual's wants. On the sides of the basin butterflies and orchids alternate. The butterflies suggest marital felicity or perhaps the attainment of great age, as they carry both these meanings, while the orchids signify the quiet, unassuming manner of the true gentleman or the shy, self-effacing, delicately perfumed Chinese lady. The rim of the basin is shown in the border across the bottom of the drawing. Its alternating bats and *shou* signify happiness and long life, respectively.

Suggested references:
Burling, Judith, and Arthur Hart: *Chinese Art*, pp. 350, 351
Williams, C. A. S.: *Encyclopedia of Chinese Symbolism and Art Motives*, p. 298 (orchid)

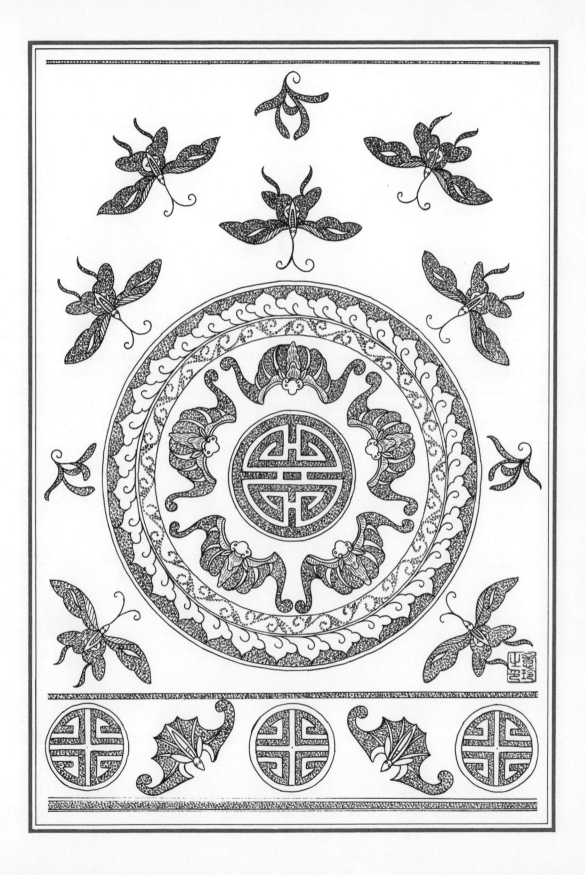

36

THE ROUND SHOU surrounded by five bats, which represent the five happinesses, is from the lid of a small brass box. The oblong design above the central medallion shows a bat flying head down, as this creature is said to do, and is taken from the design on a small brass tray. The three characters below the central medallion show three variations of the character *fu,* "happiness." The middle version was found on a piece of embroidery, and the others appeared somewhat crudely carved on the wooden cover of a Chinese folding book. The scroll border below these is a variation of a decorative design the origin and meaning of which are obscure.

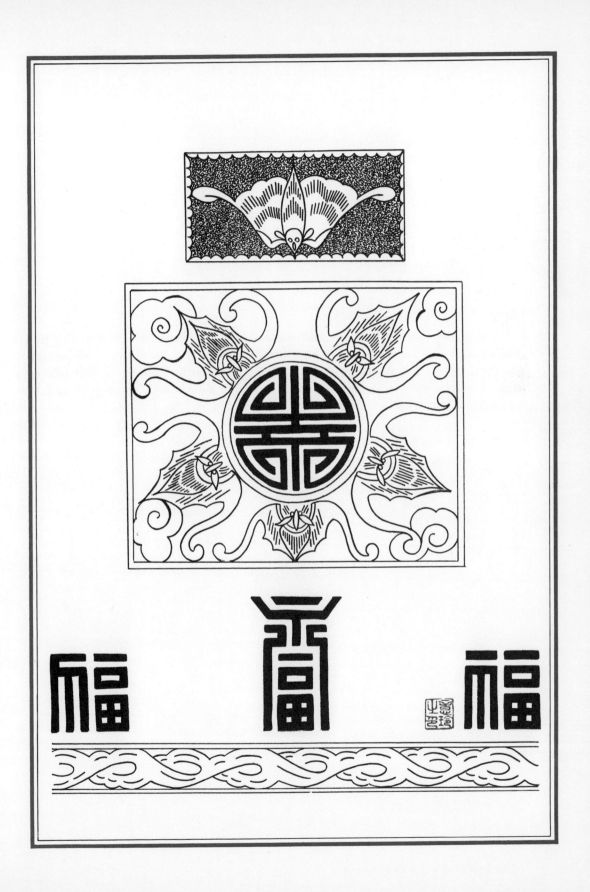

37

THESE DESIGNS ARE ALL TAKEN from brass objects. The floral borders depicting peach blossoms are from trays, and the narrow border with a variation of the scroll pattern is also from a tray. The round medallion in the center, with two dragons surrounding a form of the character *fu,* "happiness," is from a large brass bowl. The dragon at the bottom is from a brass bell.

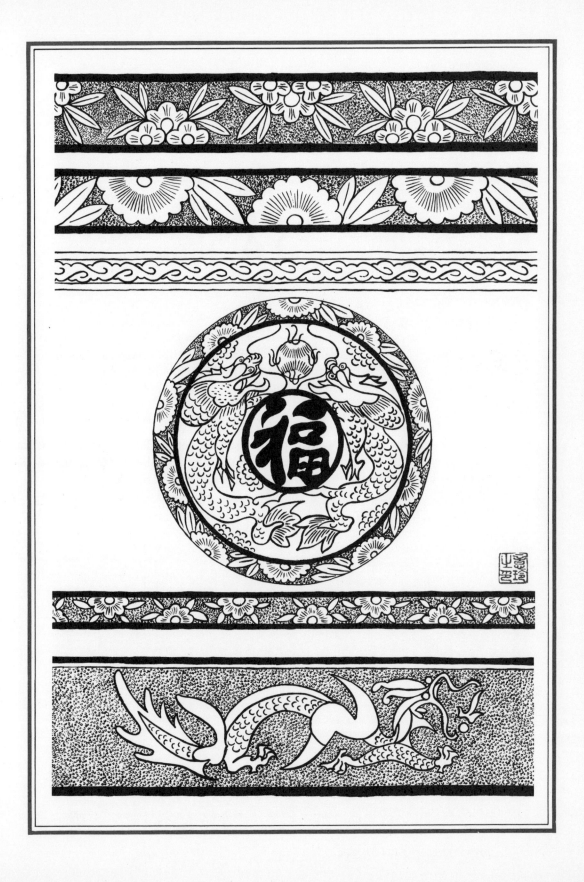

38

THE FOUR BATS stand for the four joys:

> "A gentle rain after a long drought,
> Meeting an old friend in a foreign clime,
> The joys of the wedding day,
> One's name on the list of successful candidates."*
>
> —Hsieh Chih (1369–1415)

These are from the decoration on the top of a brass tea kettle. The central motif is the design of a brass bookend; the round section encloses a form of the character *fu,* "happiness," and the base supporting this is formed by a variation of *shou,* "longevity."

* Translated by Herbert A. Giles in *A History of Chinese Literature* (New York and London, D. Appleton & Co., 1927), p. 331.

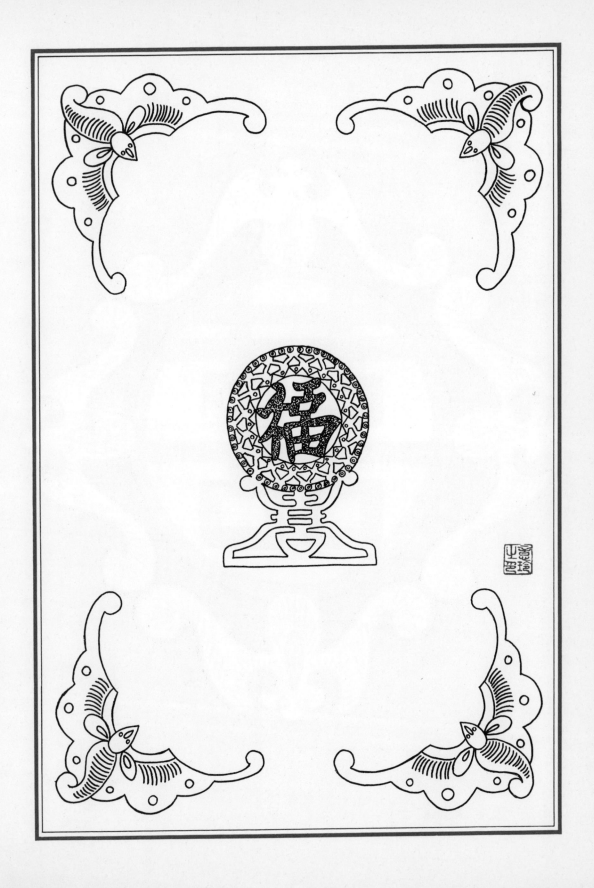

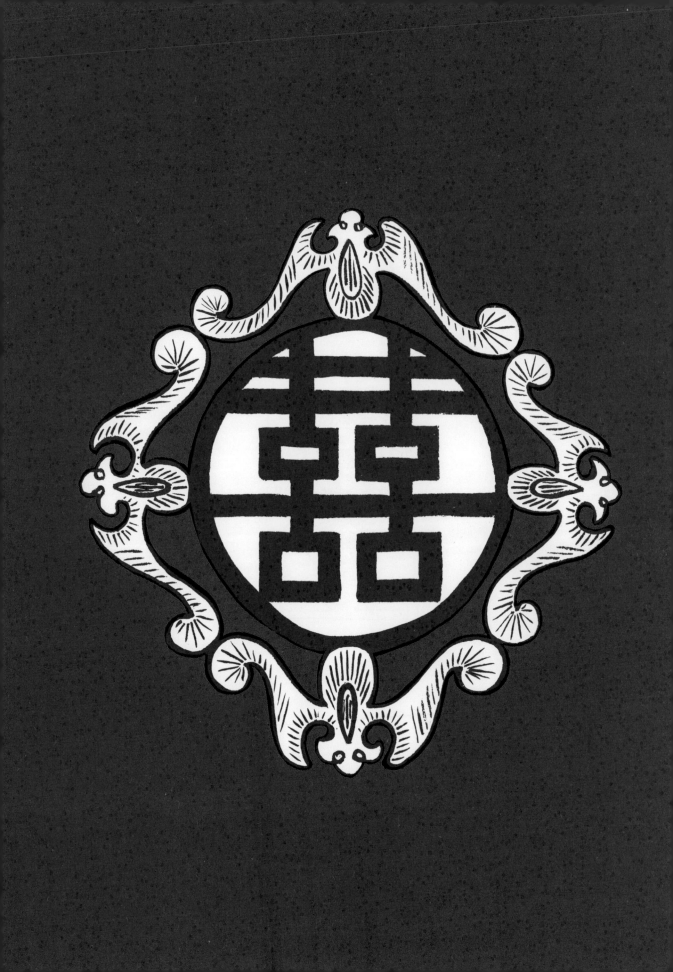

HSI

THE CHARACTERS REPRESENTED in the following three drawings are variations of *hsi*, "joy" or "happiness." There are many explanations of the character's present form, one being that it was originally a pictograph showing a drum decorated for a festival. The drum, indicating music, by extension signified joy. *Hsi* is discussed on pages 20–21.

Suggested references:
Blakney, Raymond Bernard: *A Course in the Analysis of Chinese Characters,* pp. 276–77
Chalmers, John: *An Account of the Structure of Chinese Characters,* para. 137
Karlgren, Bernhard: *Analytic Dictionary of Chinese and Sino-Japanese,* para. 129
Mathews, R. H.: *Chinese-English Dictionary*
Nott, Stanley Charles: *Chinese Jade Throughout the Ages*
Weiger, Léon: *Chinese Characters*
Wilder, G. D., and J. H. Ingram: *Analysis of Chinese Characters*

39

T HE FLORAL DESIGNS shown are of peonies and were found on various brass objects. The characters are variations of *hsi*. The version with a border of peonies and butterflies forms the design of a bookend, the floral part in pierced brass and the *hsi* in red on a green enameled background, the whole suggesting wishes for happiness, riches, and long life.

40

SHOWN HERE ARE VARIATIONS of the doubled form of the character *hsi,* "happiness" (see page 22). These are used as decorations on wedding gifts and on the boxes, sedan chairs, and hangings connected with the marriage ceremony. The medallion in the center of the page is from a modern jewel box; the four bats surrounding the double *hsi* signify the four joys (discussed in commentary 38). The borders at top and bottom are variations of the ancient design symbolic of the rolling of thunder, signifying happiness in an agricultural society, where thunder means the coming of life-giving rain.

41

THIS DESIGN WAS TAKEN from a red leather box of the kind used at weddings, and it carries an appropriate message. The geometrical design in the center is the character for happiness, *hsi,* written twice—double happiness. Around this are five bats, which indicate the five happinesses. In each of the four corners is a butterfly, emblem of joy and of conjugal felicity and also signifying immortality or the attainment of great age. For further discussion of the butterfly, see page 19.

MISCELLANEOUS MOTIFS

The six final drawings depict a number of symbolic motifs that do not fit into the seven general categories of *shou, ch'i lin, lung, fêng huang, ju-i, fu,* and *hsi*. Among these motifs are those illustrating the Four Gentlemanly Accomplishments, the attributes of the Eight Immortals, and the Eight Precious Objects. The design on this page, the "mystic knot," is one of the Eight Precious Objects and is discussed on pages 33–34.

42

THIS IS A DETAIL of a garment ornamented with emblems of happiness and longevity: the *ju-i* head, round forms of *shou* incorporating swastikas, bats, the mystic knot, and swastikas with ribbons. (The significance of the ribbons is discussed in commentary 45.)

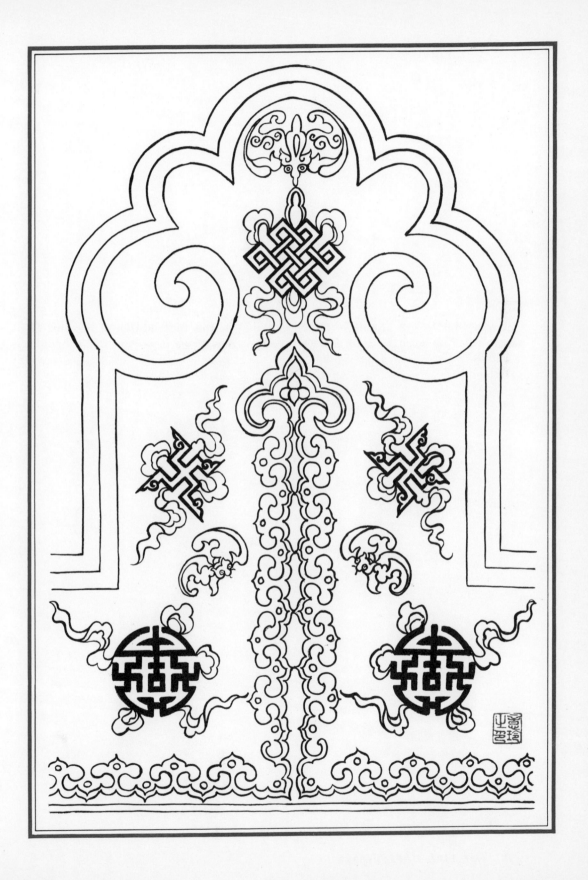

43

THESE DESIGNS ARE TAKEN from pen drawings in the 1922 edition of Edouard Cha-
vannes's *De l'expression des voeux dans l'art populaire chinois* (see page 24).

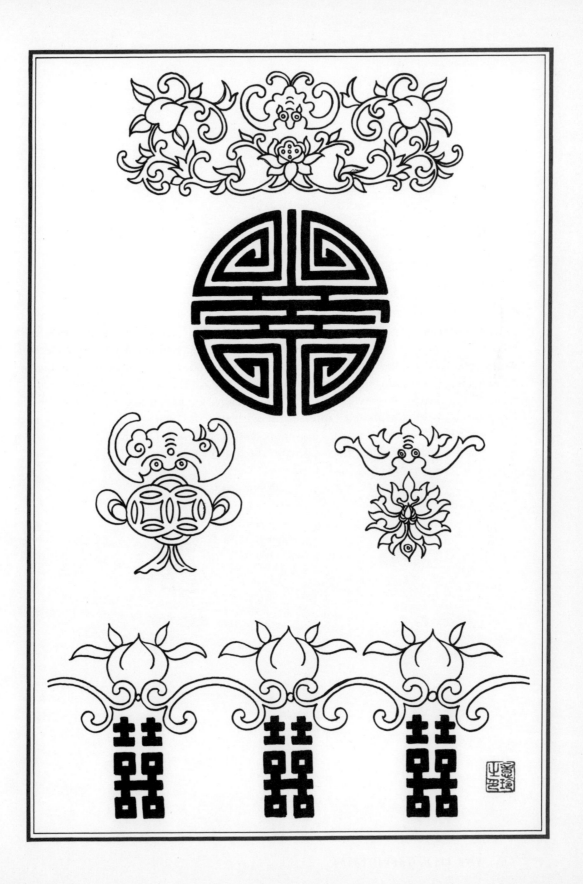

44

THE MEDALLIONS SHOWN refer to T'ai-szu, whose sons are said to have numbered a hundred (see pages 25–26). These designs are from an old camphorwood chest and constitute its only decoration. On the lid is carved the round *shou* of longevity in duplicate; on each end, the *shuang hsi,* or double happiness; and on the front the character *tzu* 子, "sons," and next to it a stylized *pai* 百, "one hundred." In addition to referring to the legendary T'ai-szu, this design expresses the wish that the owner of the chest may have the blessings of longevity, marital happiness, and many sons. The characters are shown below in the order in which they appear in the drawing.

shou 壽

shuang hsi 雙 喜

tzu 子 *pai* 百

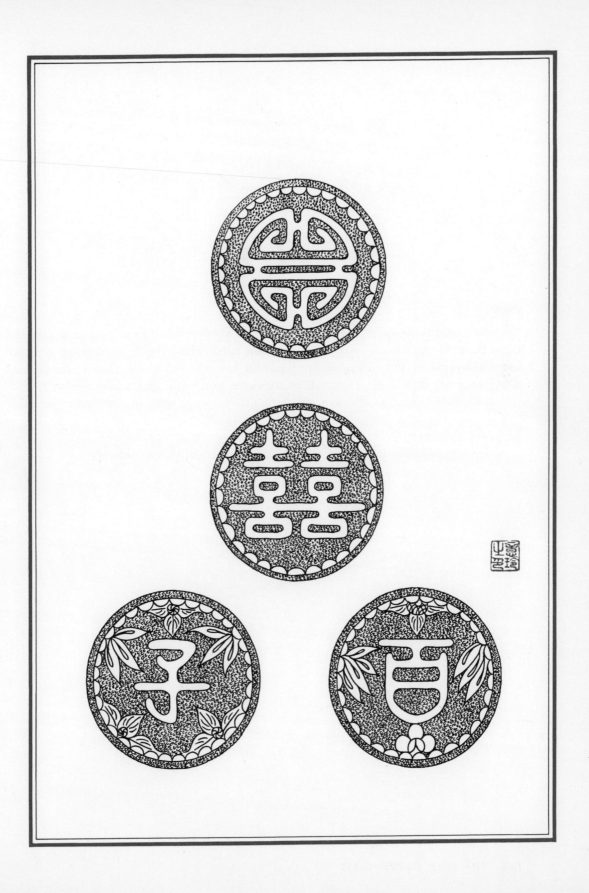

45

THESE DESIGNS SHOWING the Four Gentlemanly Accomplishments (see page 31) are taken from the decoration on a small porcelain bowl. From top to bottom are a chess board and its pieces (in two bowls), scroll paintings, a lute, and books. The ribbons shown flying about the depictions of symbols or attributes apparently have a meaning similar to that of the halo as used in Western art, setting these things apart as immortal or sacred.

Suggested reference:
Strong, Hilda Arthurs: *A Sketch of Chinese Arts and Crafts,* p. 48 (ribbons)

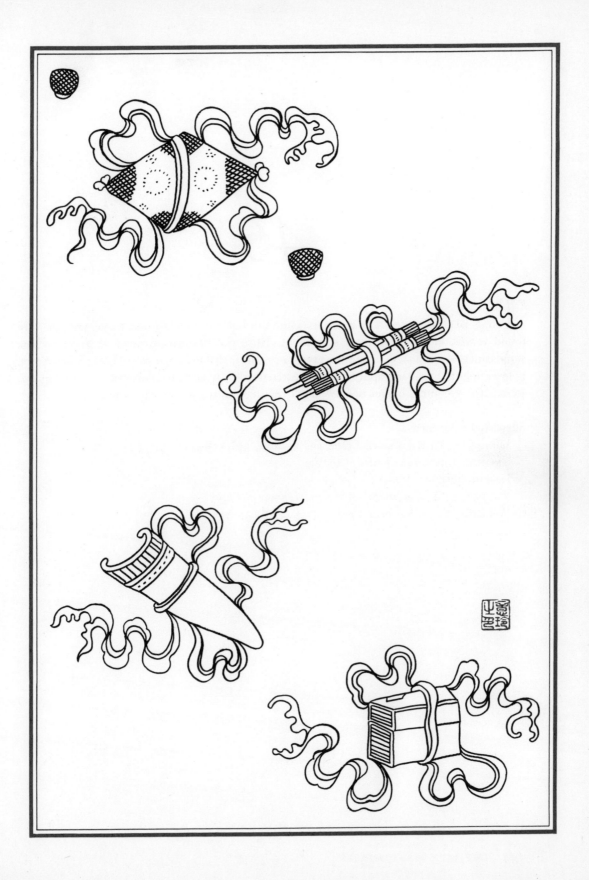

46

THESE DEPICTIONS OF THE ATTRIBUTES of the Eight Immortals (see pages 32–33) were found woven into the fabric of a garment. Note the ribbons attached to them, whose significance is discussed in commentary 45. The attributes are as follows: upper left, gourd; upper right, fan; upper center, castanets; left center, bamboo tube; right center, lotus; lower center, basket of flowers; lower left, flute; lower right, sword.

Suggested references:
 Burkhardt, V. R.: *Chinese Creeds and Customs,* pp. 158–61
 Christie, Anthony: *Chinese Mythology*
 Hackin, Joseph: *Asiatic Mythology*
 Werner, E. T. Chalmers: *Myths and Legends of China*
 Williams, C. A. S.: *Encyclopedia of Chinese Symbolism and Art Motives*

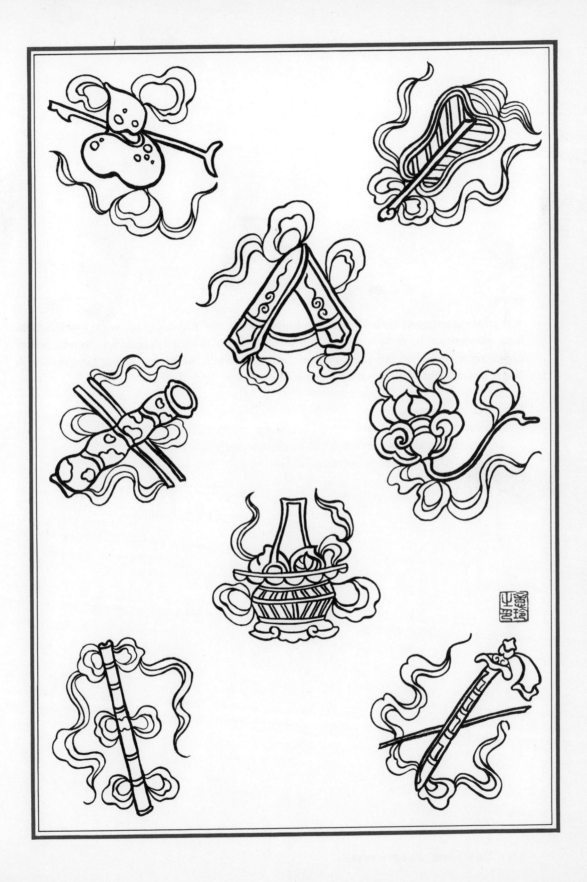

47

THESE DEPICTIONS of the Eight Precious Objects (see pages 33–34) were found on the same garment as the designs shown in drawing 46: top, canopy; upper left, mystic knot; upper right, wheel of the Law; center, fish; lower left, umbrella; lower center, conch shell; lower right, lotus; bottom, covered jar.

Suggested references:
 Medley, Margaret: *A Handbook of Chinese Art*
 Strong, Hilda Arthurs: *A Sketch of Chinese Arts and Crafts*
 Williams, C. A. S.: *Encyclopedia of Chinese Symbolism and Art Motives*

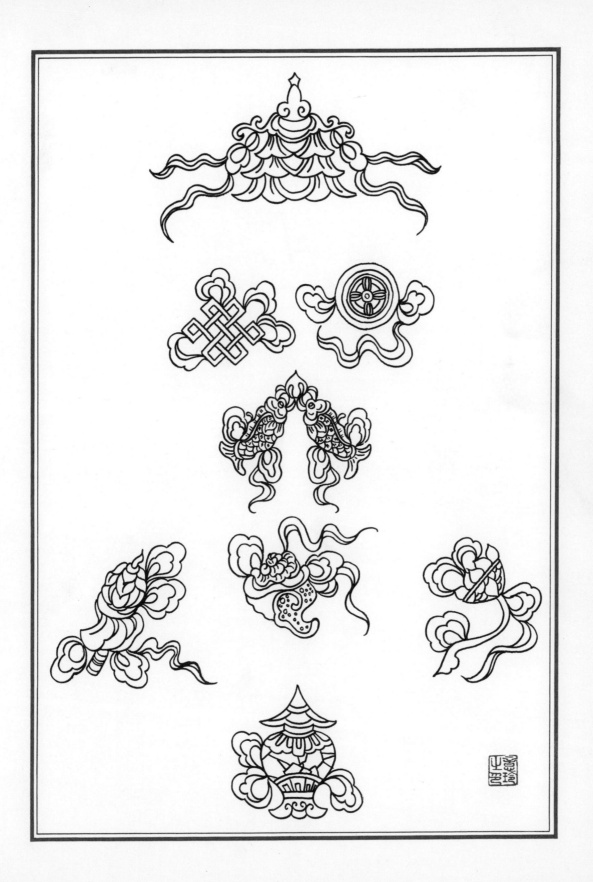

SELECTED BIBLIOGRAPHY OF WORKS BY EDOUARD CHAVANNES

"La chronologie chinoise de l'an 238 à l'an 87 avant J.C." *T'oung pao*, 1896

"Le cycle turc des douze animaux." *T'oung pao*, 1906

De l'expression des voeux dans l'art populaire chinois. 1922 (originally published in *Journal asiatique*, 1901)

"Dix inscriptions chinoises de l'Asie centrale d'après les estampages de M. Ch.-E." *Mémoires de l'Académie des inscriptions et belles-lettres*, 1902

Les documents chinois découverts par Aurel Stein dans les sables du Turkestan oriental. 1913

"Documents historiques et géographiques relatifs à Li-kiang." *T'oung pao*, 1912

"Documents sur les Tou-Kiue (Turcs) occidentaux." *T'oung pao*, 1904

Explorations of Northern China. 1902

Fables chinoises du IIIe au VIIIe siècle de notre ère (translated by Edouard Chavannes and converted into verse by Alice Dior Chavannes). 1912

"Gunavarman." *T'oung pao*, 1904

Les inscriptions des Ts'in. Extract of *Journal asiatique*, 1893

"Inscriptions et pièces de chancellerie chinoises de l'époque mongole." *T'oung pao*, 1904–5

"L'instruction d'un futur empereur de Chine en l'an 1193." *Mémoires concernant l'Asie orientale*, vol. 1

"Le jet des dragons." *Mémoires concernant l'Asie orientale*, vol. 3

"Leou Ki et sa famille." *T'oung pao*, 1914

Les livres chinois avant l'invention du papier. 1905

Mémoire composé à l'époque de la grande dynastie T'ang sur les religieux éminents qui allèrent chercher la loi dans les pays d'occident par I-tsing. 1894

Les mémoires historiques de Se-ma Ts'ien. 5 vols. 1895–1905

Mission archéologique dans la Chine septentrionale. 4 vols. 1909–15

"Les monuments de l'ancien royaume coréen de Kao keou-li." *T'oung pao*, 1908

"Note sur la peinture de Kou K'ai-tche conservée au British Museum." *T'oung pao*, 1909

"Les pays d'occident d'après le *Heou Han chou*." *T'oung pao*, 1907

"Les pays d'occident d'après le *Wei Lio*." *T'oung pao*, 1905

La peinture chinoise au Musée Cernuschi (with Raphaël Petrucci). 1914

"La peinture chinoise au Musée du Louvre." *T'oung pao*, 1904

"Le royaume de Wou et de Yue." *T'oung pao*, 1916

La sculpture à l'époque des Han. 1913

La sculpture bouddhique. 1915

La sculpture sur pierre en Chine au temps des deux premières dynasties Han. 1893

"Seng-houei." *T'oung pao,* 1909

Le T'ai Chan. 1910

"Le *Tao tö king* gravé sur pierre." *T'oung pao,* 1905

"Un traité manichéen retrouvé en Chine" (with Paul Pelliot). *Journal asiatique,* 1911–12

Tripitaka, Selections. 1910–11

"Trois généraux chinois de la dynastie des Han orientaux" (translation of Chapter 77 of *Heou Han chou*). *T'oung pao,* 1906

"Trois inscriptions relevées par M. Sylvain Charria." *T'oung pao,* 1906

"Une version chinoise du conte bouddhique de Kalyânamkara et Pâpaṃkara." *T'oung pao,* 1914

"Voyage archéologique dans la Mandchourie et dans la Chine septentrionale." *T'oung pao,* 1908

GENERAL BIBLIOGRAPHY

Ball, Katherine M. *Decorative Motives of Chinese Art*. London, Bodley Head, and New York, Dodd, Mead & Co., 1927

Barondes, R. de Rohan. *China, Lore, Legend and Lyrics*. New York, Philosophical Library, 1960

Blakney, Raymond Bernard. *A Course in the Analysis of Chinese Characters*. Shanghai, Commercial Press, 1926

Burkhardt, V. R. *Chinese Creeds and Customs*. Hong Kong, South China Morning Post, 1956

Burling, Judith, and Arthur Hart. *Chinese Art*. New York, Studio Publications in association with Bonanza Books, 1953

Chalmers, John. *An Account of the Structure of Chinese Characters*. Shanghai, Kelly & Walsh, 1911

Christie, Anthony. *Chinese Mythology*. Feltham, Middlesex, Hamlyn Publishing Group, 1968

Ferguson, John C. *The Mythology of All Races,* vol. 8. Archaeological Institute of America. Boston, Marshall Jones, 1937

Frank, Otto. "Edouard Chavannes." *Ostasiatische Zeitschrift,* vol. 6, nos. 1–2, April–September, 1917, pp. 87–94

Giles, Herbert A. *A Chinese Biographical Dictionary*. London, Bernard Quaritch, 1897

———. *A History of Chinese Literature*. New York and London, D. Appleton & Co., 1927 (copyright 1901 by D. Appleton & Co.)

———. *A History of Chinese Pictorial Art*. Shanghai, Kelly & Walsh, 1905

Goette, John. *Jade Lore*. New York, John Day, 1957

Grousset, René. *Chinese Art and Culture*. New York, Orion Press, 1959

Hackin, Joseph. *Asiatic Mythology*. New York, Thomas Y. Crowell, 1963

Hayes, L. Newton. *The Chinese Dragon*. Shanghai, Commercial Press, 1922

Hummel, Arthur W. *Eminent Chinese of the Ch'ing Period*. 2 vols. Washington, D.C., Library of Congress, 1944

Karlgren, Bernhard. *Analytic Dictionary of Chinese and Sino-Japanese*. Paris, Libraire Orientaliste Paul Geuthner, 1923

Laufer, Berthold. *Jade*. South Pasadena, California, P. D. and Ione Perkins in cooperation with Westwood Press and W. M. Hawley, 1946

Legge, James. *The Chinese Classics*. 5 vols. London, Oxford University Press, 1960 (originally published 1861–85)

Li Ch'iao-p'ing. "The Chemical Arts of Old China." *Journal of Chemical Education*. Easton, Pennsylvania, 1948

Maspero, Henri. "Edouard Chavannes." *T'oung pao,* series 2, vol. 21, 1922, pp. 43–56

Mathews, R. H. *Chinese-English Dictionary: Revised American Edition.* Cambridge, Massachusetts, Harvard University Press, 1950 (originally published 1931)

Mayers, William F. *The Chinese Reader's Manual.* Shanghai, American Presbyterian Press, 1874

Medley, Margaret. *A Handbook of Chinese Art.* New York, Horizon Press, 1965

Nott, Stanley Charles. *Chinese Jade Throughout the Ages.* Rutland, Vermont, and Tokyo, Charles E. Tuttle, 1962

————. *Voices from the Flowery Kingdom.* New York, Chinese Culture Study Group of America, 1947

Osgood, Cornelius. *Blue and White Chinese Porcelains.* New York, Ronald Press, 1956

Pope-Hennessy, Una. *Early Chinese Jades.* New York, Frederick A. Stokes, 1923

Silcock, Arnold. *Introduction to Chinese Art and History.* New York, Oxford University Press, 1948

Smith, A. H. *The Proverbs and Common Sayings of the Chinese.* Shanghai, American Presbyterian Press, 1914

Sowerby, Arthur de Carle. *Nature in Chinese Art.* New York, John Day, 1940

Strong, Hilda Arthurs. *A Sketch of Chinese Arts and Crafts.* Peking, China Booksellers, 1926

Tredwell, Winifred Reed. *Chinese Art Motives Interpreted.* New York, Knickerbocker Press, 1915

Tun Li-ch'en. *Annual Customs and Festivals in Peking.* Translated and annotated by Derk Bodde. Hong Kong, Hong Kong University Press, 1965

Watson, Burton (translator). *Complete Works of Chuang Tzu.* New York and London, Columbia University Press, 1968

Weiger, Léon. *Chinese Characters: Their Origin, Etymology, Classification, and Signification.* New York, Paragon Book Reprint Corp., with Dover Publications, 1965 (originally published 1940)

Werner, E. T. Chalmers. *Myths and Legends of China.* London, Calcutta, and Sydney, George G. Harrap & Co., 1922

Whitlock, Herbert P., and Martin L. Ehrmann. *The Story of Jade.* New York, Sheridan House, 1949

Wilder, G. D., and J. H. Ingram. *Analysis of Chinese Characters.* Peking, North China Union Language School, 1922

Willetts, William. *Chinese Art.* Baltimore, Penguin Books, 1958

Williams, C. A. S. *Encyclopedia of Chinese Symbolism and Art Motives.* New York, Julian Press, 1960

 The "weathermark" identifies this book as having been designed and produced at the Tokyo offices of John Weatherhill, Inc. Book design, typography, and layout by Dana Levy. Composition by General Printing Company, Yokohama. Platemaking and printing by Kinmei Printing Company, Tokyo. Bound at the Okamoto Binderies, Tokyo. The type-face used is 12 pt. Perpetua, with Chinese characters in hand-set Mincho and display type in hand-set Caslon Open Face.

EHREJMAX
R01 0838 9814
applied 05/01